Neue Nationalgalerie
Berlin

Prestel

Munich · Berlin · London · New York

Reprinted 2002
© 1997 by Prestel Verlag,
Munich · Berlin · London · New York

© of works illustrated: p. 128

© of plans inside front cover: Lohan
Archive (Mies van der Rohe Office),
Chicago. Photograph by Hedrich
Blessing

Photographs by Jörg P. Anders,
Reinhard Friedrich, Gerhard Murza,
Werner Zellien, and Jens Ziehe,
Berlin

Edited by Roland März and Angela
Schneider

Front cover illustration:
Max Beckmann, *Portrait of the
Heinrich George Family*, 1935
(see no. 77)

Prestel Verlag
Mandlstrasse 26 · 80802 Munich
Tel. +49 (89) 38 17 09-0
Fax +49 (89) 38 17 09-35

4 Bloomsbury Place ·
London WC1A 2QA
Tel. +44 (20) 7323-5004
Fax +44 (20) 7636-8004

175 Fifth Avenue · New York
NY 10010
Tel. +1 (212) 995-2720
Fax +1 (212) 995-2733

www.prestel.com

Translated from the German by
John William Gabriel
Copyedited by Michele Schons
Designed by Konturwerk, Munich
Color separations by Fotolito Longo,
Frangart
Typesetting by Mega-Satz-Service,
Berlin
Printed and bound by Passavia
Druckerei GmbH, Passau

Printed in Germany on
acid-free paper
ISBN 3-7913-1732-6
(English edition)
ISBN 3-7913-1595-1
(German edition)

Neue Nationalgalerie
Staatliche Museen zu Berlin —
Stiftung Preussischer Kulturbesitz
Potsdamer Strasse 50
D-10785 Berlin, Germany
Tel. +49 (30) 266 26 51
Fax +49 (30) 262 47 15

Opening Hours
Daily except Mondays 9 a.m.
to 5 p.m.
Saturdays and Sundays 10 a.m.
to 5 p.m.

Museum Education and Visitor
Service
For information on guided group
tours,
call +49 (30) 830 14 66 / 203 554 44

Regular Tours
Scheduled every other Sunday
at 11 a.m.

Appraisals
Paintings and sculptures appraised
Wednesdays and Fridays from 10
to 12 a.m.

Cafeteria
Open daily except Mondays 9 a.m.
to 5 p.m.
Saturdays and Sundays 10 a.m.
to 5 p.m.

Frequent visitors to the Neue Natio-
nalgalerie enjoy many advantages by
becoming a member of its Supporters
Association. For information on how
to join, contact

Verein der Freunde der
Nationalgalerie
Rankestrasse 21
D-10789 Berlin, Germany
Tel. +49 (30) 214 96 187
Fax +49 (30) 214 96 100

Contents

History of the Museum

The present guide describes the collection on view in the Neue Nationalgalerie (New National Gallery), yet this represents only a part of the holdings of the Nationalgalerie proper, which are now distributed among three main sites. Nineteenth-century art is housed in our original building, the Alte Nationalgalerie on Museumsinsel (built from 1866 to 1876 to designs by August Stüler and Heinrich Strack). Our second venue, the Neue Nationalgalerie, is devoted to art from early modernism to the 1960s and 1970s. Located at the edge of Tiergarten park, it was designed by Mies van der Rohe and built from 1965 to 1968. With Hans Scharoun's Philharmonic Hall and State Library, the Neue Nationalgalerie formed the nucleus of the Kulturforum (Arts Forum), which since has been expanded by a new Museum of Decorative Art and Gallery of Painting, Department of Prints and Drawings, and Arts Library. Thirdly and finally, there is the former Hamburger Bahnhof (Hamburg railway terminal), recently redesigned by Josef Paul Kleihues, which presents contemporary art in all media and includes the Marx Collection.

In addition to these principal venues, there are, in Charlottenburg, the Berggruen Collection ("Picasso and His Era") and the Galerie der Romantik, whose holdings will be relocated in the Alte Nationalgalerie when reconstruction work there is completed. Friedrichswerder Church in Berlin-Mitte is being converted into a Schinkel Museum devoted to Berlin sculpture of the nineteenth century.

The cornerstone of the collection was laid in 1861, with a bequest by Consul Wagener to the king of Prussia. By the turn of the century, under Hugo von Tschudi, the German collection had been augmented by works from other European countries and by contemporary art. Ludwig Justi then gathered these holdings into an independent department, which was opened in 1919 at the Kronprinzenpalais (Crown Prince's Palace). During the 1920s and early 1930s the museum developed into one of the leading collections of contemporary art in the world. Then came a brutal caesura: in 1937 the Nazis' campaign against "degenerate" art involved confiscation of over 400 works — a blow from which the Nationalgalerie has never fully recovered.

Evacuated during the war, the depleted collection returned in 1948 to a divided city and a divided museum. In 1959, the holdings that had come under Allied control in Wiesbaden and Celle found a provisional home at the Orangerie in Charlottenburg. In the meantime, another institution had come into existence: the Galerie des 20. Jahrhunderts (Gallery of the 20th Century), established in 1945 by the Magistrate of Greater Berlin as a replacement for the Kronprinzenpalais, which had been destroyed in the war. Headed by Adolf Jannasch, the Galerie was moved to West Berlin and reopened in 1954 on Jebensstrasse, immediately behind Zoo Station. Then came 1961 and the Wall, which suddenly made large portions of the collections inaccessible to people in the West.

In West Berlin administrative conflicts threatened to arise between the Galerie des 20. Jahrhunderts and the Nationalgalerie, headed by Leopold Reidemeister in a dual function as museum director and first director general of a new foundation, the Staatliche Museen Stiftung Preussischer Kulturbesitz. To solve the problem, the *Land* of Berlin (West) agreed to place all its holdings under the administration of the federally operated and funded foundation.

The site where this amalgamation took place was the Neue Nationalgalerie, opened in 1968 with Werner Haftmann as its director. Mies van der Rohe's austere structure owes

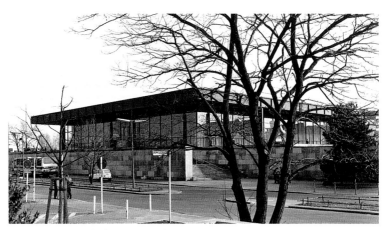

The Neue Nationalgalerie viewed from the north, 1993

much to the Prussian tradition, ultimately going back to the architecture of Karl Friedrich Schinkel. Its steel-frame, coffered roof is supported on eight pylons. With inset glazed walls reaching from floor to ceiling, the building is like a spacious hall, a covered plaza, as it were, which permits extreme flexibility of use. Measuring 50 meters square, the roof is 8.5 meters high at the center; but towards the sides it droops by about twelve centimeters, a masterly touch on Mies's part to mitigate the ponderous appearance of the steel slab and create an impression of lightness and grace. The foundation or socle on which the hall stands is actually the museum building proper, where the permanent collection is housed. The interior is divided by load-bearing walls and movable partitions in such a way as to provide multiple views from space to space, underscoring visual relationships among the items on exhibition. The entire back wall of the lower floor opens onto a sculpture garden. With a ceiling height of four meters, 4,900 square meters of exhibition space, and about 800 running meters of walls, the interior of the socle is a great deal more spacious than it appears from the outside.

After 1945 the two sections of the Nationalgalerie in East and West developed along divergent lines. As the western section reflected European and international trends, the eastern retained a national focus, concentrating on GDR art and presenting it in Schinkel's Altes Museum. With the aid of important temporary exhibitions, the Neue Nationalgalerie continued, and expanded upon, the prewar role of the Kronprinzenpalais, a role that, in due course, it will relinquish to the Hamburger Bahnhof.

The amalgamation of the collections was a considerably smoother process in the nineteenth century than in the twentieth, after the fall of the Wall. As witnessed by the "Art Battle" that resounded through the German media in 1994, the road towards rapprochement was a rocky one, and necessitated a reassessment of values on the part of all concerned. If there is anything that distinguishes the Neue Nationalgalerie from comparable institutions in the Western world, and perhaps makes it unique, it is surely the historical fissure that runs through the collection and determines its present character.

At unification, the Nationalgalerie (East) held 772 paintings and 454 sculptures of the twentieth century, and the Nationalgalerie (West) 757 paintings and 345 sculptures and environments — a total of 2,328 works of various sizes and equally

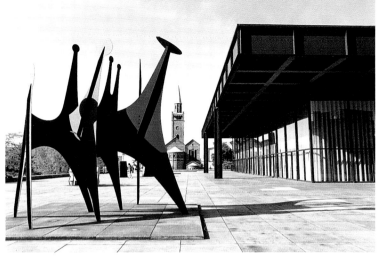

Alexander Calder's *Têtes et queue* (Heads and Tails) of 1965 on the terrace

diverse styles. If one mentally projects these stocks onto the floor plan and wall space of the Neue Nationalgalerie, it becomes obvious why the first step in amalgamation had to be a paring down and thematic simplification of the work on show.

The strengths and weaknesses of the collection are easily described. The Nazis' almost total banishment of twentieth-century art has not yet been made good, despite great efforts, especially on the part of our supporters association, re-established after the war, the Verein der Freunde der Nationalgalerie. It has proven possible to reacquire certain works and to replace major confiscated paintings and sculptures with others by the same artists. The Expressionist period, for instance, thanks in part to loans of outstanding works, is once again superbly represented. The Critical Realists of the 1920s, above all Grosz and Dix, the acquisition of whose *Skat Players* we owe to the initiative of the Verein der Freunde, form a magnificent high point. Dada, with works from the estate of Hannah Höch, as well as Klee and Feininger, are well represented. Kokoschka is now presented in a depth perhaps unmatched by any other German museum. Our collection of postwar art has been wonderfully augmented by the Otto van de Loo bequest of key works by members of the Cobra group. *L'Art brut*, with works by Jean Dubuffet, and *L'Art informel* are well represented, as are Zero and *Nouveau Réalisme*, all the way down to American Color Field Painting, including Barnett Newman's major canvas *Who's Afraid of Red, Yellow and Blue IV*.

We can offer no more than an excerpt from the history of modern and contemporary art, but it is one that, through all the rooms in the Nationalgalerie, is lent unity by the self-determination of the modern artist, from Caspar David Friedrich (Alte Nationalgalerie and Galerie der Romantik) to Joseph Beuys (Hamburger Bahnhof). No other German museum illustrates this more compellingly than the Nationalgalerie, to whose collection three separate museum guides are devoted.

Our venues have common roots, yet each defines its own unique identity within the context of the enormous diversity that is modern art.

DH

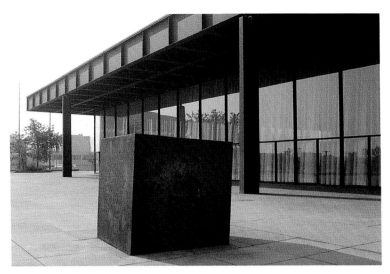

Richard Serra's *Berlin Block for Charlie Chaplin* of 1978

Sculpture on the Terrace

Visitors to the Neue Nationalgalerie are bound to pass by one of the two sculptures that flank the broad sweep of the building's cornice. To the left rises a tall metal pole with four movable square elements, George Rickey's *Four Squares in a Square* of 1969. On the right is Henry Moore's massive bronze *Archer* of 1964–65. These two very different works provide a suitable introduction to a superb ensemble of sculptures that compellingly illustrates various stages and directions in twentieth-century European and American art. The presentation is not chronological, but is determined by aesthetic criteria. The sculptures, collected over a period of some three decades under museum directors Werner Haftmann (1967–74) and Dieter Honisch (since 1975), are arranged such that each work has ample space to unfold, to speak unhindered to the viewer. The terrace is devoted exclusively to metal sculpture in its various forms and styles, with the deliberate exception of polychrome pieces.

Archer by Henry Moore (1898–1986), of which a second cast is located on Nathan Philips Square in Toronto, exemplifies the tensely juxtaposed two-part configurations to which Moore returned in the 1960s. The figure's rounded forms, which swell voluminously into the surrounding space and draw space into the sculpture, reflect an approach governed by the plastic core: organic form remains the English sculptor's key point of reference. At the northwest corner of the museum stands the chrome-nickel steel sculpture *Hercules* (1971–72) by Brigitte and Martin Matschinsky-Denninghoff (b. 1923 and 1921), an artist-couple who have been working in collaboration since 1954. The stark contrast between sinuous, tubular forms and static, blocklike elements derives from a technology-influenced idiom that aims to infuse lifeless matter with a sense of whimsical animation.

The aspect of play is also characteristic of the work of Alexander Calder (1898–1976). His *Têtes et queue* (Heads and Tails), a "stabile" of 1965, reflects a Surrealist sensibility for bizarrely figurative, vitally evocative form. The composition of flat shapes, emerging fanlike from one another, resembles certain industrial-

ly produced objects, reflecting the American artist's training as an engineer. Calder's famous "mobiles" were first shown in 1932 at the Galerie Maeght in Paris. In 1949, along with the work of László Moholy-Nagy and Naum Gabo, they would inspire his compatriot, George Rickey (b. 1907), to launch into kinetic sculpture.

Rickey has been closely associated with Berlin since 1962. His work addresses motion, and its embodiment of both timelessness and incessant change. "Nature is seldom motionless," wrote Rickey in 1963. "The entire environment is in motion, in conformance with one rhythm or another, in one direction or another, based on laws that at once signify manifestations of nature and subjects of art." Rickey's art reflects one of the fundamental approaches espoused by modern sculptors: the piece is no longer under-stood as a "symbol of something" but a self-sufficient, self-contained "sign"; or, in current parlance, the immaterial, or free energies, are transmuted into an object of art. This is also apparent in a number of other sculptures that come into view as we continue around the building. Greek sculptor Joannis Avramidis (b. 1922), in his *Polis* of 1965, employs a close-packed group of semi-abstract human figures to evoke the strictures of physical existence. The aluminum piece *Fuendetodos* (1974) by Eduardo Paolozzi, an artist of Italian origin born in Scotland in 1924, rhythmically combines truncated technological forms into robot-like object-figures that seem part machine, part playground implement. Spanish sculptor Eduardo Chillida (b. 1924) evokes an imaginary relationship between physical body and empty space in his life-size iron monument *Gudari* (1975). From the solidly rooted metal base, the piece branches upwards and outwards, the linear elements jutting into space like levers. But for all their intrinsic tension they seem strangely without

orientation, as if to suggest an existential search, beginning in the roots of the past, to find a meaningful place in the here and now.

This path of abstraction was followed most persistently by a younger generation. American sculptor James Reineking (b. 1937), whose circular, slightly inclined ground piece *Touching I* (1971–78) immediately strikes the eye, has described his approach by stating that, as soon as a borderline exists, even the idea of one, we tend to make value judgments, attaching different values to what is inside and out. Such fundamental considerations have become an increasingly compelling concern of contemporary sculpture. Another case in point is the work of Canadian artist Royden Rabinowitch (b. 1942), whose 1988 piece *Four Handed Developed Surfaces Opposed* was acquired that year by the Nationalgalerie from the exhibition "Zeitlos". While Rabinowitch is known primarily for flat sculptures that rise only minimally above floor level, in the mid-1980s he began creating objects in the shape of truncated cones formed of steel plates bent in various ways. By juxtaposing pairs of such objects, the artist jolts conventional perceptions of space and heightens our awareness of it.

We now come upon two steel sculptures by Alf Lechner (b. 1925), the almost imperceptible curve of the over seven-meter long *Steel Leaf No. 5: Spherical Section* (1986) and the aggressive, but sharply defined linearity of *Tetrahedral Subtraction* (1987). Both pieces derive their effect from the precision and the potentially infinite extension of geometric forms. *Berlin Block for Charlie Chaplin*, a 1978 piece by Richard Serra (b. 1939), is undoubtedly one of the highlights of the Neue Nationalgalerie sculpture collection. The great wrought-iron block, two cubic meters weighing 72 tons, is inset in the terrace at a slight angle, as if it had fallen from a great height. In

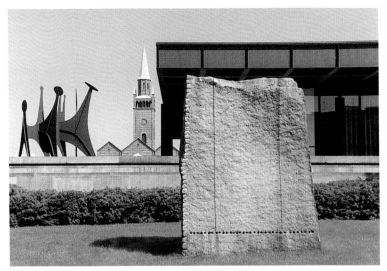

View of the terrace, with sculptures by Alexander Calder and Ulrich Rückriem

relation to the transparent, functional museum building it creates a disturbance, and indeed, the sculpture was positioned by the artist himself with a view to establishing a solid counterweight to the light-flooded architecture.

The metal sculptures on the terrace have been supplemented since 1985 by stone pieces installed on the lawn along the south side of the Neue Nationalgalerie. *Granite (Normandy), Split, Cut* of 1985 by German artist Ulrich Rückriem (b. 1938) consists of a vertical slab of rough-hewn stone bearing only a few, but striking, signs of working, while the 1984–85 *Stone* by Austrian Karl Prantl (b. 1923), embedded in the lawn, is a painstakingly chiseled piece whose wavelike configuration links it with the landscaping. Both works can be described as stones of meditation.

Sculpture in the Garden

In the informal surroundings of the sculpture garden the visitor can acquaint him- or herself with a wide range of twentieth-century European sculpture, from the figurative to the abstract. Grouped in front of *Three Vertical Motifs* of 1968 by Bernhard Heiliger (1915–95), a semi-abstract symbiosis of vegetative growth and organic structure, are three sculptures of female nudes. The first, the earliest piece in the garden, dates from 1917–18: *Large Washerwoman* by Auguste Renoir (1841–1919), in which the soft curves of the artist's painted nudes blossom into three dimensions. Celebration of sensuality is also the keynote of *Autumn*, a 1948 figure by Henri Laurens (1885–1954). Yet here the body has been abstracted into an elementary plastic symbol evocative of sheer physical vitality. *Dreamer* (1964) by Waldemar Grzimek (1918–1984) has the precarious corporeality characteristic of the German realistic tradition in sculpture, of which Gerhard Marcks (1889–1981) is a prime exponent. His *Maya* of 1942 combines naturalism with statuesque presence. The same is true of the somewhat more austere *Large Striding Figure* (first version, 1921) by Ernesto de Fiori's (1884–1945) in the right-hand section of the garden. Also found here are abstract sculptures by Nikolaus Gerhart (b. 1944), *Drilling XI*, a

Gerhard Marcks's *Maya* of 1942 and Bernhard Heisig's *Three Vertical Motifs* of 1968 in the sculpture garden

pavement and to the cool tectonics of the building. In the left-hand section of the garden a further abstract sign is set by the interlocked iron planes of *Three Elements*, a 1979–81 work by Hungarian sculptor István Nádler (b. 1938), while pieces by German sculptors Otto Herbert Hajek (b. 1927), Wilhelm Loth (1920–1993), and Bernhard Luginbühl (b. 1929) evince a combination of reference to nature and free design. In Hajek's *Forest of Leaves* of 1960 vegetative forms entwine with solid substance, and in Loth's 1968–70 *On the Beach* organic fragments are confined in a boxlike object. Luginbühl seemingly harnesses technological forces to shape an alienated, machine-like montage-sculpture, *Punch* (1966). The garden display is rounded off by two figurative works, *The Cry* of 1963 by Marino Marini (1901–1980) and *Large Neeberg Figure* of 1971–74 by Wieland Förster (b. 1930). If Förster's extremely elongated female nude evokes the bonds of existence, Marini's horse and fallen rider embody the abrupt breaks and ruptures that are a fundamental principle of his style. *FJ*

two-part piece of 1985, and Erich Hauser (b. 1930), *Steel 4/63* of 1963, in which metal plates are transformed into an innovative, elementary sign. "I'm not interested in working like nature," said Hauser in 1968. "What interests me is creating forms at odds with nature." The austere configuration of Ulrich Rückriem's five-part stone piece *Untitled* of 1978 relates both to the pattern of the

Painting and Sculpture of the Twentieth Century

Contributors:

		Jörg Makarinus	JM
Eugen Blume	EB	Hans Jürgen Papies	HJP
Sibylle Gross	SG	Britta Schmitz	BS
Dieter Honisch	DH	Angela Schneider	AS
Fritz Jacobi	FJ	Manfred Tschirner	MT
Roland März	RM	Friedegund Weidemann	FW

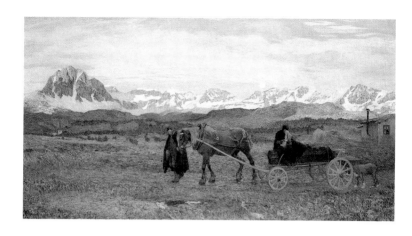

Giovanni Segantini (1858–1899)

1 *Homecoming* 1895
Oil on canvas, 161.5 x 299 cm

Returning with his family from Milan, Segantini settled in 1894 in Maloja, Switzerland, where *Homecoming* was painted. The image derives from an experience the artist had in Savognin, where, as F. Servais records, Segantini saw "how a family brought a dead son back home on a cart." As we know from Segantini's letters, he shifted the scene to the Maloja region and depicted one of its mountain chains rising in the background. This combination of two disparate motifs reflects the artist's attempt to create an art in which nothing relied on chance, neither content nor composition. Segantini's approach was influenced initially by north Italian naturalism of the late nineteenth century. He often projected into his renderings of the Alpine world and the people who live there an existential metaphor, clothing them in religious ideals and utopian socialist ideas. Around 1887, similarly to Seurat, Segantini developed a divisionist technique, in which the color scale was separated into complementary hues applied to the canvas in short strokes or dabs. This, he said in 1891, would help him achieve his aim of making every work "an expression of the self in its

connection with Nature," a work whose painting technique would convey the "mystery of facture," the making process itself. The simplicity of the composition owes much to the influence of Millet's paintings. The mountain panorama, however, is not purely illustrative in intention: within the context of Segantini's oeuvre, such snow-capped peaks are a metaphor for the anonymous face of death and its power over humankind. The composition is built up accordingly, with a strict parallelism between the path and horsedrawn cart, the horizontal bands of light and shadow, and the mountain chain in the background, which closes the pictorial space like a majestic stage backdrop. *JM*

Ferdinand Hodler (1853–1918)

2 *Young Man Admired by Woman II* ca. 1904
Oil on canvas, 206 x 244 cm
On loan from the Kunsthaus, Zurich
(Gottfried Keller-Stiftung)

In his symbolic figurative compositions Hodler took up a theme that, thanks to Freud, played a key role in Viennese art and literature: the tension-rife relationship between the sexes. The first version of the present painting, done in 1903, was shown in 1904 at the XIX Viennese Seces-

sion. In his 1904 version of the erotic round dance Hodler simplified the composition, background, and figures, tautening contours and emphasizing their rhythms in order to express the idea of the perpetual dance of the sexes in more universal terms. The serial arrangement of the figures, and the repetition and reversal of compositional elements, were further means to this end, as was parallelism, which Hodler

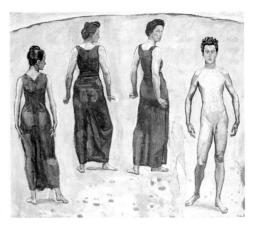

raised to a principle. A striving for the universal is seen also in the vaguely suggested landscape, which evokes the earth's curvature. Hodler's son, Hector, modeled for the idealized adolescent boy, and his rather austere admirers resemble the women in the artist's life, Berthe Jacques and Jeanne Charles-Cerani. *FW*

Ferdinand Hodler (1853–1918)

3 *The Orator* 1912
Oil on canvas, 251 x 143.5 cm

In 1911, on the recommendation of Max Liebermann, Hodler received a commission from the city of Hanover to paint a large mural in an assembly room at the recently finished town hall. The subject was stipulated: the conversion of the citizenry to the Reformation, which occurred on the marketplace in 1533. After two years of work on the approximately fifteen-meter-long, four-part mural on canvas, titled *Unanimity*, the room was formally opened in June 1913. For the central figure of the orator, on the panel located over the door, Hodler made over 180 preliminary drawings and painted 6 canvases, of which our version is the largest and probably the final one. Representing the fiery Reformer, Arnsberg, clad in red to underscore his charisma, the figure was modeled on the artist's son, Hec-

tor. The low vantage point underscores the drama of Arnsberg's wide-legged stance on the platform, his impassioned expression, and the gesture of his hands as he swears allegiance to Luther's church. The stylized figure silhouetted against the sky celebrates the ideal of unity, which, according to Hodler's theory of parallelism, was intrinsic to all things and must reveal itself as "a new order" in the work of art. *FW*

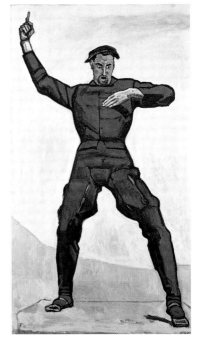

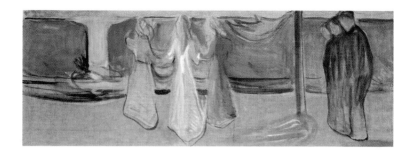

Edvard Munch
(1863–1944)

4 *Desire* 1906–07
Panel from the Reinhardt
Frieze
Tempera on canvas,
91 x 252 cm

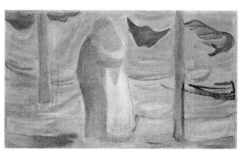

Norwegian artist Edvard
Munch lived principally in
Berlin from 1892 to 1908.
In 1906 he was asked by
Max Reinhardt, the actor and stage
director, to paint a frieze for the new
Kammerspiele playhouse on Schu-
mannstrasse (nos. 4–7). Munch
began the work in the summer of
1906, at Bad Kösen, and completed
it in late 1907 in Berlin. The twelve
panels are painted in thinned tem-
pera on unprimed canvas, to create
a frescolike effect. They were install-
ed in the oval Festival Hall on the
second floor of the theater, between
the windows immediately below the
ceiling. "The motif," said Munch in
1907, "stems from the beach outside
my house in Aasgaardstrand —
ladies and gentlemen on a summer
night." The undulating line of the
beach links all twelve panels, with
their atmosphere of a midsummer
night. The original sequence of these
"wall decorations" is not recorded.
They continue Munch's "Frieze of
Life" theme of the 1890s (Loneliness
— Melancholy — Love — The Dance
— Death), in a complete and coher-
ent cycle. *Desire* is another of the
artist's variations on the theme of
the perpetual underlying tension
between male and female — the

temptations, attempted fulfillment,
and ultimate disappointment of Eros.
We see three girls on the beach,
facing away from us and holding
hands, as if joined in a ritual dance
addressed to the moon and its erotic
emanations. The group of young
men, merged into a statuesque unity,
look on in longing expectation,
bound by destiny to the opposite sex.

RM

Edvard Munch (1863–1944)

5 *Couple on the Beach* 1906–07
Panel from the Reinhardt Frieze
Tempera on canvas, 90 x 155 cm

The theme of couples (also as *Two
People*, or *The Lonely Ones*) preoc-
cupied Munch after 1891. Here he
transposes the motif of the kiss from
an interior to the coastline, where the
lovers tenderly embrace under two
pine trees. Just to their right is a
wind-blown branch whose shape
recalls a mouth pursed in a kiss — a
symbol for the emotional and sexual
attraction between man and woman.
"The two at the moment when they

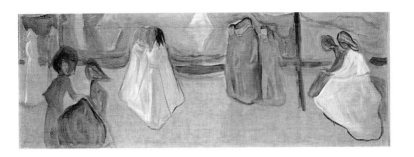

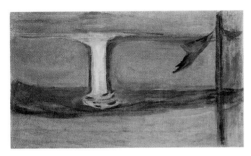

Edvard Munch
(1863–1944)

7 *Aasgaard Beach* 1906–07
Panel from the Reinhardt Frieze
Tempera on canvas, 91 x 157.5 cm

In 1897 Munch bought a summer cottage on Aasgaardstrand overlooking Oslo Fjord. In this panel of the frieze the beach appears as a "pure" landscape, entirely without figures. In the subdued light of a northern summer night, the moon, obscured by clouds, is a golden column in the blue water. The spare fir tree's branches lend wings to the meditative landscape. As Munch said: "Through the depiction of this landscape one is transported into an image of one's own mood — this mood is the main thing — nature is only a means. The degree to which the image resembles nature is insignificant."

The twelve panels of the Reinhardt Frieze remained together only briefly. The hall was altered in 1912, and the frieze removed and exhibited in 1914 at the Galerie Gurlitt, Berlin, where the panels were sold individually. In 1930 the Nationalgalerie acquired two panels from the collection of Curt Glaser, Berlin (confiscated as "degenerate" in 1937 and never recovered). Eight panels were purchased for the Neue Nationalgalerie in 1966, supplemented by *Dance on the Beach*, on loan from an Oslo private collection, in 1995.

are no longer themselves but only a link in the chain of a thousand generations." (Munch) *RM*

Edvard Munch (1863–1944)

6 *Summer Night* 1906–07
Panel from the Reinhardt Frieze
Tempera on canvas, 91 x 252 cm

This panel has the most figures in the frieze. At the far left a woman and man talk quietly, with two girls in the foreground. The group of girls just left of center is drawn together in a pyramidal form, what P. Krieger describes as "a constellation of three crystals — a cosmic simile." This rhombic group is repeated in the boats and their reflections. To the right of the girls in their light, diaphanous dresses several young men form an amorphous, dull-hued configuration pointing up the contrast between the sexes. At the far right two women of different ages represent the ages of life and its transience. In Munch's words: "The bright summer night, in which life and death, day and night go hand in hand." *RM*

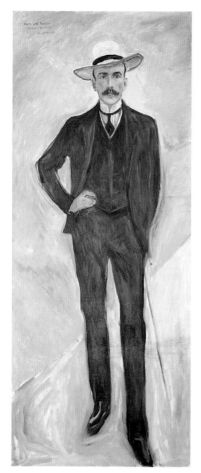

Edvard Munch (1863–1944)

8 *Harry, Count Kessler* 1906
Oil on canvas, 200 x 84 cm

From their first meeting in 1895 in Berlin, Count Kessler (1868–1937) remained a faithful supporter and benefactor of Munch. In 1903 Kessler became head of the Grand Ducal Museum of Fine and Applied Arts in Weimar and, at his suggestion, Munch was accepted into the Association of German Artists in 1904. His portrait of this advocate of the European avant-garde was done from July 9 to 11, 1906, in a studio at the Weimar Academy. Kessler is depicted standing before an indeterminate background suffused with light, a dapper, refined, sensitive man, a citizen of the world, gazing candidly at the viewer. Munch always thought of portraits as the "bodyguards" of his oeuvre. Kessler retired from his position in 1906 and left Weimar a "free man." Until 1933 he was active as a diplomat, member of the German Society for Peace, and advocate of the League of Nations. He died in French exile in 1937. *RM*

The remaining three paintings are in the Museum Folkwang, Essen, the Hamburg Kunsthalle, and a private collection in Oslo. *RM*

Edvard Munch
(1863–1944)

9 *Lübeck Harbor with the Holstentor* 1907
Oil on canvas, 84 x 130 cm

In 1902 Munch made the acquaintance of Dr. Max Linde, a Lübeck ophthalmologist and art collector. Over the next few years he created a number of portraits of the Linde family, a frieze for the children's room, and the Linde Portfolio. Returning to Lübeck in spring 1907, Munch painted two views of the harbor with its landmark, the Holstentor, as seen from Hotel Kaiserhof (the other view, *Lübeck Harbor*, is in the

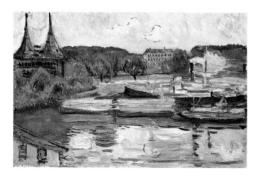

Kunsthaus, Zurich). The focus of interest is shifted from the old town gate, rising at the far left, to the freighters and barges moored on the bank of the Trave River, with quay and boulevards extending into the background. The brilliant palette of the painting, influenced by Fauvism, reflects Munch's short-lived "newfound peace of mind." *RM*

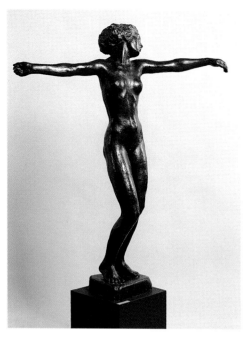

Georg Kolbe
(1877–1947)

10 *Dancer* 1911–12
Bronze, 154 x 127 x 88 cm

The graceful *Dancer* brought Kolbe early fame and established his reputation as a sensitive modeler of the human figure. "In early years," recalled the sculptor in 1923, "I used to model my figures straight from life and worked for that reason in clay. In front of nature I pursued the outward life of phenomena — pursued the tiniest half-lights and half-shadows.... My well-known *Dancer* was done back then and still holds its own despite that." Shown at the Berlin Secession in 1912, the piece was acquired by the Nationalgalerie before the year was out. Kolbe had been working in Berlin since 1903. His turn to sculpture, after an initial study of painting, had come in 1898, when he met Louis Tuaillon in Rome. The present work is obviously influenced by Auguste Rodin, whose Meudon studio Kolbe visited in 1909. The expansive gesture that opens the figure out to the surrounding space, the impressionistic dissolution of the surface, and the spiraling motion of the figure, which is equally effective from every viewpoint — all this recalls Rodin, though Kolbe steered clear of the Frenchman's existential themes. The nude combines inward concentration with physical exuberance to produce a melodiousness of motion that perfectly captures the sense of weightlessness felt in dance. In keeping with his preference for girlish figures, Kolbe modeled the *Dancer* on eighteen-year-old Charlotte Kaprolat, the future wife of his painter-friend Max Pechstein. Accepted into the Prussian Academy of Arts in 1919, Kolbe continued to devote himself to sylphlike figures. In the 1930s he turned to maturer models, whose forms he often idealized to the point of pathos. Never again would Kolbe achieve the unbound yet demure grace seen in his *Dancer*. *FJ*

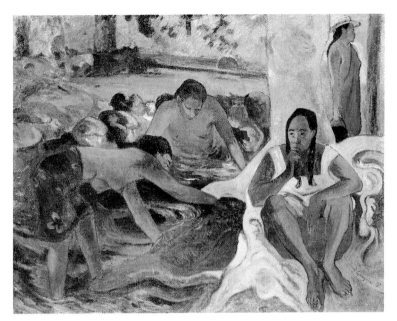

Paul Gauguin (1848–1903)

11 *Tahitian Fisherwomen* 1891
Oil on canvas, 71 x 90 cm
On permanent loan from the Ernst von
Siemens-Stiftung, Munich

Painted on heavy burlap, signed and dated, this picture was painted during the early part of Gauguin's first sojourn on Tahiti. After a final trip to France, he settled permanently in French Polynesia in 1895. The painting shows a scene from the rural environs of the island's capital, Papeete, which Gauguin thought too European in character. What he sought was "a land of archaic customs."

Three young women are depicted on the banks of a stream, their rhythmically contoured figures forming a semicircle open towards the viewer. A fourth girl carrying a pail of water walks past, behind the tree at the right. The movements and poses, though seemingly exotic, actually derive from earlier Western art, for they can be traced back to compositions by Poussin, Ingres, Delacroix, and others. The seated figure at the right, for instance, is found in a pastel by Degas, whom Gauguin very much admired. And not only the pose, but also the melancholy mood of the woman suggests European roots. As in many other Gauguin paintings, the evocation of an earthly paradise is based on compositional patterns found in Western art or, occasionally, in the art of Egypt or Java (Borobodur). Yet Gauguin possessed a unique ability to blend an exotic world with European artistic traditions, which made him a legendary ideal not only for the following generation of Expressionists, but also for artists and art-lovers to this day.

AS

Max Pechstein (1881–1955)

12 *Seated Female Nude* 1910
Oil on canvas, 80 x 70 cm

This sensuous nude, rendered in the spontaneously applied flat areas of brilliant color and the dynamic, simplified contours typical of the style of the *Brücke* group around 1910, was painted at the Moritzburg Ponds near Dresden. Pechstein had come from Berlin to paint there with the group,

both outdoors and in the studio. The *Brücke* had been founded in Dresden in 1905 by architecture students Fritz Bleyl, Erich Heckel, Ernst Ludwig Kirchner, and Karl Schmidt-Rottluff. The artists in the group lived and worked together; its name — which means "bridge" and thus evokes a crossing to unexplored shores — was derived from Nietzsche's *Thus Spake Zarathustra*. Pechstein became a member in 1906, followed in 1910 by Otto Mueller; Emil Nolde, too, belonged for a time. The group's artistic models were Gauguin, Van Gogh, Matisse, and Munch; in the magic of the supposedly primitive art of the South Pacific they found means of expression undiluted by convention. In 1913, after their move to Berlin and the publication of Kirchner's *Chronicle*, the group dissolved, and the outbreak of the First World War threw each artist back upon himself. *FW*

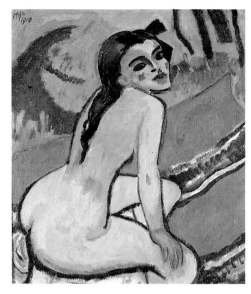

Staberhof, a small farmhouse, illuminated by a ray of sun breaking through the storm clouds, as wind whips the trees into tossing, fanlike shapes. Slate gray paths diverge and disappear in the woods, except for one that leads straight to the house. Along it hurries a tiny, shadowy figure of a kind familiar from Kirchner's agitated Berlin paintings. His rendering of proliferating nature — to which the human figure is almost wholly incidental — may be seen to anticipate the free-form abstraction of *L'Art informel* and Action Painting. *RM*

Ernst Ludwig Kirchner
(1880–1938)

13 *House Among Trees — Fehmarn*
1913
Oil on canvas, 90.5 x 121 cm

This canvas was created on Fehmarn Island in the Baltic Sea, where Kirchner and his companion Erna Schilling spent their summers from 1912 to 1914. "I have painted pictures of absolute maturity there," wrote the artist in 1912, "... ocher, blue, and green are the colors of Fehmarn." Kirchner shows the

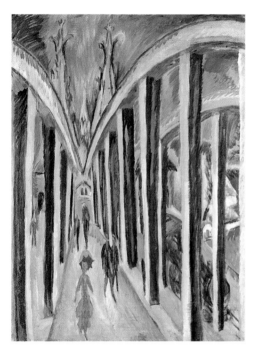

Ernst Ludwig Kirchner
(1880–1938)

14 *Bridge over the Rhine in Cologne* 1914
Oil on canvas, 120.5 x 91 cm

In May and July 1914 Kirchner was in Cologne to design a booth at the International *Werkbund* Exhibition for Josef Feinhals, a tobacco dealer and art collector. The Hohenzollern Bridge, opened in 1911, intrigued the artist as a visual counterpoint to Cologne Cathedral. A modern engineering structure set against Gothic spires relates the inward thrust of the bridge to the "futuristic" counteracting motion of the locomotive at the lower right. The exaggerated perspective pulls the viewer into the image, sweeping arcs are set against solid verticals, permanence coexists with flux. Ludwig Justi saw a "dainty little lady in pink. Fluent strokes, very delicate colors, and a strange tension between well-nigh sinister grandeur and playful insouciance." The canvas is one of Kirchner's major metropolitan images. *RM*

Ernst Ludwig Kirchner
(1880–1938)

15 *Potsdamer Platz*
1914
Oil on canvas, 200 x 150 cm
On loan from a private collection

This nocturnal image of the famous square in Berlin was finished in autumn 1914, after Kirchner's return from Fehmarn Island. The building in the center background is Potsdam Station, reduced to an arcaded loggia, its clock showing twelve. To its left is the Café Piccadilly, opened by Kempinski in 1913 and patriotically rechristened "Haus Vaterland" after the outbreak of war. Visible at the right is a section of the Pschorr Building, shorn of several stories. Against this architectural backdrop two nearly life-size female figures, streetwalkers, play the starring role on the oval stage of a traffic island. One is disguised in a widow's veil, livid greenish face, flaming red hair, unapproachable. The slender figure of the younger woman in Prussian blue tapers skywards. In their isolation the pantomimic figures embody youth and aging, self-confidence and resignation. Behind the chimeric females, potential clients in black approach with giant strides.

Kirchner roamed the city by night and gained an intimate knowledge of its enticements and frustrations. These he evokes in a formal idiom of contrasts: figures set against stone, large forms against small, oval against wedge. Angular, somehow Gothic shapes penetrate rounded, organic ones; people and place interact in a tense urban forcefield of sightlines. The subtle palette, too, relies on contrasts: green against gray, bluish black against pinkish red.

In *Potsdamer Platz* Kirchner unfolds a panorama unlike his other, closely cropped street scenes. Painted just after the outbreak of war, this magnificent canvas sums up his intellectual and existential experience of Berlin: the metropolis as a marketplace of Eros, with its inextricable enmeshment of the sexes. *RM*

Ernst Ludwig Kirchner
(1880–1938)

16 *Standing Woman* 1912
Alder, height 99 cm

The "primitive" sculptures in the Dresden Museum of Ethnology inspired Kirchner and the *Brücke* artists to create, around 1905, their first starkly angular, simplified figures in wood, "where every hollow and bulge is formed by the sensuousness of the maker's hand, where a sharp slash and the tenderest carving immediately convey the artist's feeling."

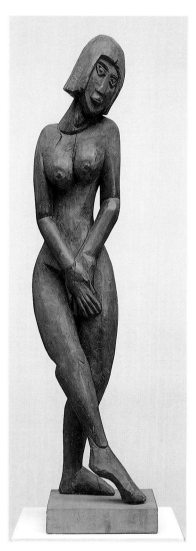

ette, are characteristic of the harsh style of the Berlin period, which supplanted Kirchner's earlier, more archaic approach. As the painter-sculptor wrote in 1914: "Involvement with sculpture is becoming increasingly valuable to me; it makes it easier to translate spatial conceptions into the plane, just as earlier it helped me find comprehensive, coherent form." *RM*

Ernst Ludwig Kirchner
(1880–1938)

17 *The Dance Between two Women* 1919
Wood, 173.5 x 82 cm
On loan from a private collection

Kirchner carved this double-sided relief, on two separate panels that were later glued together, in Frauen-

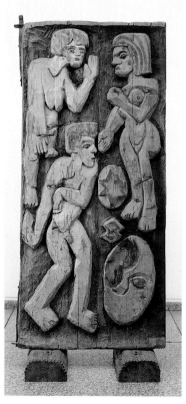

(Kirchner, 1925). *Standing Woman*, done in Berlin in 1912, was carved in a supple alder wood that later developed cracks. The nude figure, which resembles Erna Schilling, is posed such that the limbs describe a gentle spiral around the central axis of the body. Its visual interest derives from the contrast between the crossed legs, the doll-like joints of the arms, the modest gesture of the hands, and the inclined head, its features reduced to signlike shapes. Such traits, suggestive of a marion-

kirch near Davos, Switzerland, in spring 1919. The male figure on the front (illustrated here) is a self-portrait of the artist, accompanied by the moon and two stars, dancing between two women, on the right Erna Schilling. The wood shows traces of polychome treatment, in light, cool hues on the left panel and a warm, darker tone on the right. On the reverse, an Alpine scene is compressed into a shallow space, to be read from bottom to top.

The symbolic triangle of a man caught between two women was depicted by Kirchner in two paintings and several prints of 1919. Though some believe that the artist intended to use the relief as a studio door, there is no evidence for this. At first intended for Henry van de Velde's residences in Uttwil on Lake Constance, it was, in 1942, installed as a door in Lise Gujer's house, "Gruoba," in Sergital, near Davos. Seven bronze casts exist of this major relief of the Swiss period, which, as K. Gabler says, "Kirchner created for himself at a crucial turning point in his life." *RM*

Otto Mueller (1874–1930)

18 *Summer Day* 1921–22
Distemper on canvas, 80 x 98 cm

Otto Mueller began teaching at the Breslau Academy in 1919. Inspired by a summer holiday the next year on the North Sea island of Föhr, he began a series of large-format canvases representing bathers and recumbent figures in a landscape. The motif of *Summer Day*, suffused with mild light and warm color, goes back to a lithograph of 1914. The nude figure in an unsullied natural ambience was a seminal theme for all the *Brücke* artists and it became central to Mueller's work in his well-known series of late paintings of gypsies. The subject reveals his profound longing for a harmonious existence untroubled by civilization. As Mueller said: "My chief aim is to express, with the greatest possible simplicity, the sense of human beings united with landscape." To achieve this arcadian vision he suppressed the individual traits of the figures. Mueller's pastorale is played on fine-tuned instruments, the paint delicate

as a veil, "lying thin and almost transparent, like pollen, along the contours. Every hue a little grayed, as if infused with a touch of powder," (Paul Westheim). The quick-drying distemper could be applied to the coarse burlap only in the studio. In Egyptian art Mueller intuitively found the technique he needed to express his striving for the elemental. *FW*

separated by sweeping contours. The dance floor, an unusually deep room, is framed by double curtains suggesting a stage. The stamping of the peasant dance is echoed by the repeated simple shapes and the three primary colors, red, blue, and yellow, accompanied by a calming green. *FW*

Erich Heckel (1883–1970)

19 *Village Dance* 1908
Oil on canvas, 67 x 74 cm

This picture is full of the *joie de vivre* of the early *Brücke* years, when the group still worked together, painting nudes, street scenes, and café interiors in and around Dresden or communing with nature during holidays on the Baltic or North Sea. *Village Dance* was painted in Dangast, where Heckel spent the summer of 1908 with Schmidt-Rottluff. Broad planes of brilliant, thinned color, are

Karl Schmidt-Rottluff
(1884 –1976)

20 *Self-Portrait with Monocle*
1910
Oil on canvas, 84 x 76.5 cm

The most forceful of the *Brücke* artists, Karl Schmidt, from Rottluff, near Chemnitz, began creating single portraits around 1910. This self-portrait

at twenty-six boldly juxtaposes fields of red, yellow, green, and orange. An almost symmetrical background concentrates our attention on the figure, whose reflecting monocle seems to fix us like a camera lens. The other eye is narrowed in creative concentration. Observation and inner vision are the essence of the Expressionist's image. *FW*

Karl Schmidt-Rottluff
(1884–1976)

21 *Farmyard in Dangast* 1910
Oil on canvas, 86.5 x 94.5 cm

In 1910 Schmidt-Rottluff was again with Heckel in Dangast, where this depiction of the Gramberg country estate was produced. Fiery reds and brilliant blues flow like lava between the buildings, whose sunny yellow, orange, and red are heightened by dark outlines. This basic color chord is supplemented by the fresh green of the trees to form the palette that characterized the work of Schmidt-Rottluff and his *Brücke* friends from 1908 to 1911. Also characteristic is the gesso-grounded canvas showing through the thinly applied, softly contoured areas of paint. The vibrant foreground dominates the stepped planes of the composition. *FW*

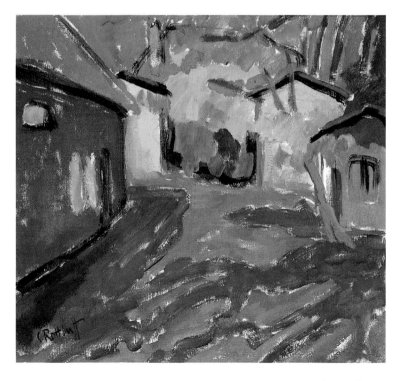

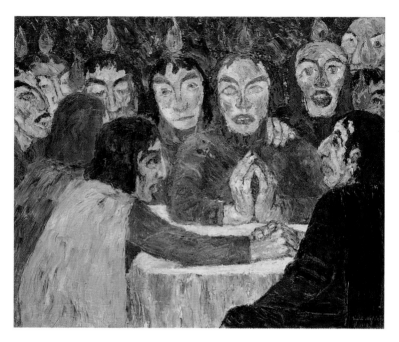

Emil Nolde (1867–1956)

22 *Pentecost* 1909
Oil on canvas, 87 x 107 cm

Emil Nolde (actually Hansen), a member of the *Brücke* group in 1906–07, has been described as a "patriarch" and a representative of "Nordic Expressionism." While staying in the fishing village of Ruttebüll on the North Sea coast in the summer of 1909, he painted his first pictures on religious themes, *The Last Supper* (Statens Museum for Kunst, Copenhagen), *The Mocking of Christ* (Brücke-Museum, Berlin), and the present visionary altar painting. *Pentecost* combines elements of the biblical Last Supper narrative with reminiscences of medieval art. The ten disciples gathered closely around the figure of Christ are based on watercolor studies of fishermen and farmers (now in the Nolde-Stiftung, Seebüll). As the artist wrote in 1934, the men are depicted "in an ecstatic, supersensory reception of the Holy Spirit ... lilac-red flames over the disciples' heads, in that divine, joyous hour when they became

Apostles. With the paintings *The Last Supper* and *Pentecost* I turned from the charm of external appearances to deeply felt inner values. They became landmarks — and that not only within my own oeuvre, I should think." Simple gestures and the intense concentration apparent in what Werner Haftmann has called "character masks of human transport" dominate the scene, which is rendered in impasto purple, violet, yellow, and blue tones that seem to radiate mystical illumination. The biblical Pentecost is depicted as a hallucinatory moment, and as a symbol of an archaic community bound together by fate.

When Nolde submitted the canvas for exhibition at the 1910 Berlin Secession, it was rejected by the jury. This sparked him and the younger Expressionists to found their own group, the Neue Secession. *Pentecost* was acquired by the Neue Nationalgalerie from the collection of Hans Fehr, a friend of the artist, in 1974. *RM*

Emil Nolde (1867–1956)

23 *Papuan Boys* 1914
Oil on canvas, 70 x 103.5 cm

In 1911–12 Nolde sketched extensively the dance masks, kachina dolls, and shrunken heads in the Berlin Museum of Ethnology, fascinated by what he called the "absolute primitiveness" and grotesque "barbarism" of the idols and sculptures of indigenous peoples. From October 1913 to early summer 1914, he and his wife Ada took part in the Medical-Demographical German Guinea Expedition, sponsored by the Imperial Colonial Office, which led by way of Siberia, Korea, Japan, and China to New Guinea, then still a German colony.

This painting of three adolescent boys, based on a postcard-size color sketch (in the Nolde-Stiftung, Seebüll), was executed in the police detainment building at Käwieng on the island of Neu-Mecklenburg, which served Nolde as a studio. It is a tensely balanced composition that emphasizes the simple existence and mythical oneness with nature of aboriginal peoples. The "window" between the boys opens on the pounding ocean, whose dynamic motion contrasts with the unyielding stasis of the figures. Similarly, the cool blues, deep turquoise, and foamy white of waves and sky are set off against the warm browns of the figures, outlined in black, and the brilliant carmine red of the two loincloths. An imponderable threat seems to pervade the scene, a lull before the storm that the Melanesians would appear to sense above the crashing of the surf. In March 1914 the artist wrote to a friend in Germany: "The aboriginal people live in their nature, are one with it and a part of the whole cosmos. Sometimes I feel that only they are still real human beings, and that we are merely like sophisticated marionettes, artificial and filled with presumption. I am painting and drawing and attempting to capture something of the primal essence.... I do think that my images of the aboriginal people ... are too authentic and stark to be hung in perfumed salons." *RM*

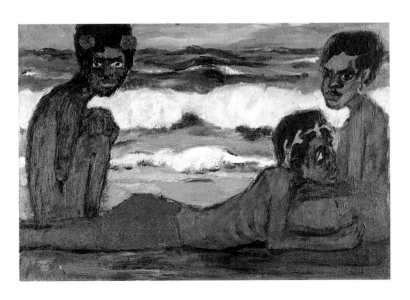

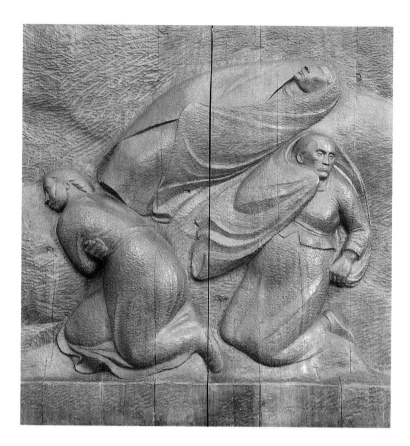

Ernst Barlach (1870–1938)

24 *The Abandoned Ones*
1912–13
Walnut, 132 x 133 x 29 cm
(two sections)

The relief depicts three women — turned away from one another — who, in their inwardly troubled isolation, seem to endure a silent existence of self-absorption and solidarity at once. While the two in the foreground seem expectantly agitated, the third, reclining figure embodies calm and mental composure. This is underscored by the lucid, closed contour of her cloak, set against the open, swirling outlines of the other two. In 1911 Barlach wrote: "I really believe that I am out with a vengeance to depict stylized humanity … heightened to giant proportions, shaken by fate or beside themselves with abandon." After his trip to Russia in 1906, which brought artistic self-discovery, the expressive, dynamic, draped figure became the prime conveyor of meaning in Barlach's work.

FJ

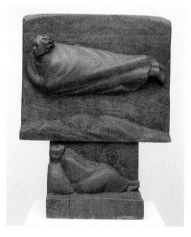

Ernst Barlach
(1870–1938)

25 *The Vision* 1912
Oak; base 40 x 57.5 x 37.5 cm, upper section 79 x 98 x 19.7 cm

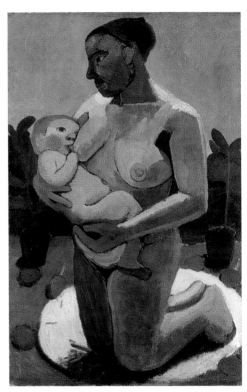

In 1916 Theodor Däubler exclaimed: "Barlach is an inkling of the cosmic and the fear thereof.... Sculpture serves Barlach as a means to verify a spirituality. To proclaim to the world: he is an Expressionist!" The existential dualism that impelled German Expressionism is clearly evident in *The Vision*. The tension between the heavy, earthy female figure below, constricted in a narrow space yet as if awaiting divine release, and the male figure enigmatically gliding through a boundless space above, reflects the contrariety between a passive, earthbound existence and the active energies of the metaphysical — both of which Barlach considered to be elemental forces of nature. *FJ*

Paula Modersohn-Becker
(1876–1907)

26 *Kneeling Mother with Child at Her Breast* 1907
Oil tempera on canvas, 113 x 74 cm

Paula Modersohn-Becker died at the age of thirty-one, after the birth of her only child. This existential image, celebrating the miracle of life, was painted in her Paris studio the previous year. The picture is dominated by the life-size nude figure of a kneeling mother with child, rising pyramidally above a bright oval disk on the grayish ground of what is apparently an outdoor scene. The illuminated disk suggests the cycle of life, and elevates the figure to a level of sublime monumentality. The woman's head is turned aside and in shadow; only the lower lip is emphasized with a touch of color. In contrast, the shoulders, breasts, and lower legs glow with illumination. The strong, heavy body is depicted in three-quarter view; its voluminosity is given form by large, sharply contoured patches of light and dark, which are fixed to the picture plane by means of outlines and shadows. The infant, cradled and protected in its mother's arms, lies at her breast. The pair is framed, slightly asymmetrically, by the dark green foliage of immature gum trees and the orange-colored fruit at right and left. The subdued reds and greens are simultaneously eclipsed and enhanced by perennial symbols of human and vegetative fertility. In the background a deep turquoise sky surrounds mother and child with an aura of magical festiveness. This symbolistic approach, the Mediterranean

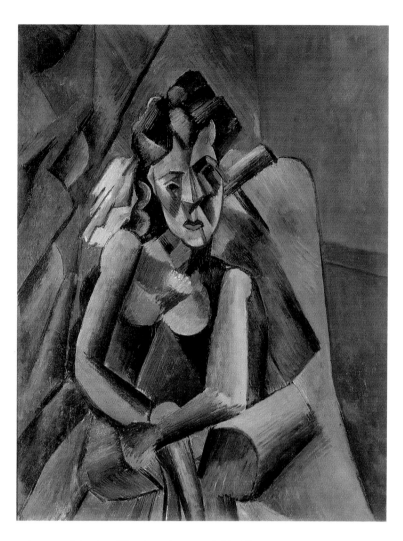

palette, and the simplification of form all point to the influence of Gauguin, whose work deeply impressed Modersohn-Becker at the memorial exhibition held in the "Salon d'Automne" the year before. In addition, her high esteem for Cézanne's masterly handling of tectonic planes had an impact on her art. The continued significance of Modersohn-Becker's work for the avant-garde lies especially in her sculptural treatment of the figure, which was encouraged by an encounter with the sculptor Bernhard Hoetger in Paris. *FW*

Pablo Picasso (1881–1973)

27 *Woman Seated in an Armchair*
1909
Oil on canvas, 100 x 80 cm

After completing *Les Demoiselles d'Avignon* in 1907, Picasso, in collaboration with Braque and influenced by Cézanne, developed Analytic Cubism, which offered entirely new possibilities in depicting objects on the two-dimensional plane. *Woman Seated in an Armchair* is a work of this period that demonstrates all of the features and problems of early Cubism. By means of X-ray

photographs that revealed a rejected version underneath the final paint layer, the sitter was securely identified as Fernande Olivier, Picasso's companion at that time. The primitivistic style that preceded Cubism, developed out of an involvement with Black African and Polynesian art, is still evident here, though the division of the figure into segments shaded in various color gradations fully embodies the Cubist approach. The armchair, curtain, and baseboard along the far wall of the room seem to have resisted the artist's attempts to divorce them from a realistic context and integrate them into the overall planar rhythm of Cubist faceting. The emphasis on narrative aspects shows affinities with the period before Picasso's trip to Horta de Ebro and such paintings as *Woman with a Mandolin* and *Woman with a Fan*.

EB

Pablo Picasso
(1881–1973)

28 *Woman Playing a Violin* 1911
Oil on canvas, 92 x 65 cm
On loan from a private collection

This canvas dates to the period of Analytic Cubism, which Braque and Picasso developed largely from the summer of 1911 to the winter of 1912, and which lent their works of the time great formal similarity. Although the title provides a clear reference, it is actually quite difficult to make out the figure of the violin player and her instrument, which have been divided into numerous smaller shapes distributed across the picture plane. The broken, often short lines that simultaneously enclose the disjoint-

ed spaces and open them out, call to mind musical notations and intervals. Though Picasso flatly denied knowing the slightest thing about music, his and the other Cubists' preference for the motifs of musicians and musical instruments would seem to reflect mental parallels between acoustic and visual phenomena. We do know that Picasso was much more interested in the anthropomorphic, feminine shape of stringed instruments, especially the guitar, than in the music they can produce. Still, the tones issuing from the violinist's instrument here do seem manifested in the way the pictorial segments detach themselves and pervade the space around the figure. As Braque wrote in 1954: "... the musical instrument, as an object, was peculiar in that a touch could bring it to life." It is just this touch of the fingers on the instrument that appears to animate the *Woman Playing a Violin* and the entire pictorial space.

EB

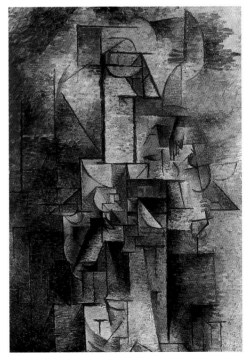

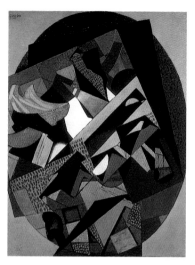

Juan Gris (1887–1927)

29 *Still Life* 1915
Oil on canvas, 116 x 90 cm

Spanish artist Juan Gris, alongside Braque and his compatriot, Picasso, was among the major representatives of Synthetic Cubism. Gris's style is in fact inconceivable without Picasso, who was a close friend. Yet Gris subjected Cubism to an analysis so searching that it led to an aesthetic and formal purity that was quite his own. The *Still Life* of June 1915 approaches pure abstraction to a degree seen in no other work of Gris. Here he permits himself the artistic liberty of blending the characteristic Cubist objects — fruit bowl, caraffe, glass, and tabletop — into an indissoluble pictorial whole. After returning to his Paris studio in 1915, the artist was gripped by a strange disquiet that for a brief time led him to break with the static compositional principle that had governed his work till then. Though unlike Braque and Picasso a master of static form, Gris created a series of extremely agitated pictures in the summer of 1915. "The major painting in the series," said Daniel Henry Kahnweiler, "is indicatively an oval inserted into the rectangle of the canvas. But instead of resting solidly and immovably, securely anchored in the base of the rectangle and attached to its sides as usual, the objects on the oval form now seem to find no hold, rotating wildly in an endless whirl." The reduction of these objects to flat segments that appear to be sliding down a tabletop shifted to the left, out of the solid vertical axis of the oval, represents a radical break with Gris's previous approach to composition.

EB

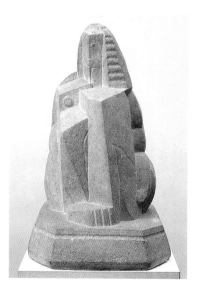

Henri Laurens (1885–1954)

30 *Crouching Woman* 1922
Limestone, 53 x 33 x 29.5 cm

Laurens was the most significant sculptor in French Cubism. His *Crouching Woman*, though modest in size, evinces a blocklike configuration of the interpenetrating volumes of the figure's limbs and a stylized head reduced to a series of planes that fulfill all the criteria of the Cubist approach. The planes, pushed up against each other and arranged at various depths emphasized by the degree to which they catch the impinging light, suggest a multiple perspective likely influenced by the two-dimensionality of Cubist paint-

ing. Nor would the limestone figure be thinkable without Laurens's Cubist reliefs. The advancing and receding shapes are staggered in the plane to create a single vantage point that achieves what a sculpture designed to be viewed from all angles reveals only when we move around it. Laurens has not reduced the natural forms of the female figure to flat-sided segments, as one might think. In fact, he has done just the opposite: by arranging Cubistic elements to create an equilibrium in space, he has found a correspondence

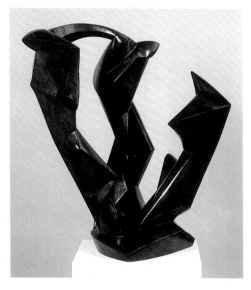

that approaches the configuration of a crouching woman. "Sculpture essentially means taking possession of space," said Laurens in 1952, "constructing a thing with hollows and volumes, mass and void, their variations and contrasts, continual reciprocal tension, and, finally, their weight." *EB*

Rudolf Belling (1886–1972)

31 *Triad* 1919 (1924)
Birch, stained in mahogany and polished, 91 x 77 x 77 cm

Triad was conceived as a design for a six-meter-high sculpture, in front of which performances of contemporary music were to be held. It consists of three highly abstracted figures of dancers, which represent the three arts of painting, sculpture, and architecture. Invoking the unity of the arts, the work embodies the synthesis of space and plastic volume, Belling envisaged, the interpenetration of closed and open form, which was his definition of sculpture. "To my mind, sculpture is first and foremost a spa-

tial concept," he noted in 1920. "That is why I treat air in the same way as solid matter, and manage to make the delineated space, previously known as 'dead form,' represent the same aesthetic value as that which defines it, the worked material." The bizarre formal rhythms emerging from the base combine human and plantlike forms in a vibrant spatial composition. As if shooting up from roots, the three elements seem to grow irresistibly skywards — a fantastic configuration that blends lyricism with formal rigor. Articulated in terms of pyramidal passages, the piece contrasts a burnished angularity with a smooth, contiguous surface. Cubism, the sculptures of Archipenko, but also the Futurists' reverence for materials are all detectable as formal predecessors in Belling's design.

At the behest of Ludwig Justi, Belling in 1924 made this version in wood from his original plaster maquette. It has since come to represent the major work of German avant-garde sculpture of the 1920s in the Nationalgalerie collection. *FJ*

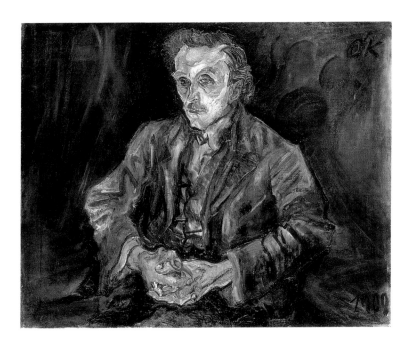

Oskar Kokoschka (1886–1980)

32 *The Viennese Architect Adolf Loos* 1909
Oil on canvas, 74 x 91 cm

Adolf Loos and Kokoschka met each other in July 1909, at the premiere of Kokoschka's play, *Mörder: Hoffnung der Frauen*, at the "Internationale Kunstschau" exhibition in Vienna. "Having made his acquaintance," recalled the artist in 1951, "was decisive not only for my life.... He taught me to see and learn ... to conceive of painting as a diary of experience." Loos also encouraged "OK" to leave his position of designer in the Wiener Werkstätte and work freelance. Kokoschka portrayed his friend — partly in return for a new suit Loos had had made for him — in October 1909, in an apartment designed by the architect on Giselastrasse. The seated figure, depicted to the knees, is placed just off the central axis of the canvas, against a stark dark blue background dramatically suffused with streams and fields of paint. The dark, loose-fitting jacket is rendered in thin oil, with folds and contours

indicated by rapid impasto strokes. The black creases in the vest give the eerie impression of revealing the rib cage beneath. Kokoschka's aim is "not to state external things," but to evoke the inward unrest and mental strain to which Loos is subject. The opposite pole to the intellectual's weary, ascetic features is seen in his overlarge and capable hands, whose red contours underscore the energy contained in them. This portrayal of intermediate states is uniquely characteristic of Kokoschka's portraiture.

FW

Oskar Kokoschka (1886–1980)

33 *Portrait of Bessie Loos* 1910
Oil on canvas, 73 x 91 cm

Kokoschka portrayed Loos and his English spouse, the former dancer Elisabeth Bruce, in quick succession. The young lady was at the Mont Blanc lung sanatorium in Switzerland when Kokoschka and Loos visited her in January 1910, and she sat for this portrait. The twenty-three-year-old, recalled the artist in 1971,

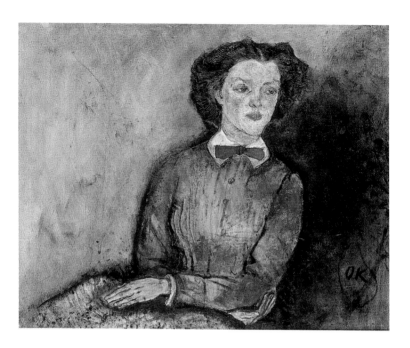

"had the laugh of a cheerful child, even when she spat blood into the notorious blue flask." The etherial figure is set against a background that exhibits a dramatic transition from light to dark, and signs of her malady are invoked by translucent hues. While the head with its feverish cheeks is surrounded by warm tones, the long, slender hands are accented by a diaphanous blue. Employing an unusually delicate palette, Kokoschka penetrates the brave front and captures the very substance of the anguished creature's suffering, hovering between life and death. *FW*

Oskar Kokoschka (1886–1980)

34 *Pariser Platz in Berlin* 1926
Oil on canvas, 76.5 x 110 cm

This is among the earliest of Kokoschka's many city views, one of a series of panoramas painted during travels between 1923 and 1933, funded by the Galerie Cassirer in Berlin. From the painter's vantage point on a balcony of the Hotel Adlon, our eye sweeps across the expanse of the square, to the focal point in its center, Brandenburg Gate, by Langhans, crowned by Schadow's *Quadriga*. Kokoschka's

characteristic spatial arrangement of two perspective vanishing points on an ellipse, lends the composition both dynamic movement and a sense of instability. The distorted lineatures and vibrant color heighten the impression of bustling urban life on the historic Berlin square. *FW*

Wassily Kandinsky (1866–1944)

35 *Sketch (Rider)* 1909
Oil on cardboard, 67 x 100 cm
On loan from a private collection

After training in economics and law, Kandinsky left Russia in 1896 to study painting in Munich. In 1909 he founded the "Neue Künstlerver-einigung München" (New Artists' Association, Munich). The motif of the horseman or rider, often depicted as a blue-cloaked knight or as St. George, the dragon slayer, had begun to appear as early as in 1901 in avant-garde Symbolist art, as a meta-phor signifying a new beginning, courage, struggle, and redemption. Kandinsky's 1909 *Rider* was a pre-liminary sketch for *Improvisation 4* (Museum of Art, Gorki). The artist considered his improvisations "unconscious, mostly spontaneously emerging expressions of the process-es of innate character, that is, impres-sions of an 'inner nature'." Here, a rider on a rearing horse, his cloak spread open, dominates the "inner nature" of a mountainous landscape. He is flanked by two trees, under the left of which crouches a figure whose red hair resembles a halo. Painted on brown-ish cardboard, the black-contoured forms derive their effect from a corres-pondence between pas-sages of yellow and green (horse, sky, tree) and orange (sun, horse's tail). Here still in the Garden of Eden, Kandinsky's rider would later rise into cosmic realms. As August Macke said: "His impetuous riders are the coat of arms hanging in front of his house." *RM*

Franz Marc (1880–1916)

36 *Three Horses II* 1913
Oil on canvas, 59 x 80.5 cm
On loan from a private collection

Wassily Kandinsky and Franz Marc founded an artists' group, *Der Blaue Reiter* (The Blue Rider) in 1911, and published an almanach of the same name. As Kandinsky recalled in 1930, "We both loved blue — Marc horses, I riders. So the name suggest-ed itself." In 1915 Marc said he "con-sidered people 'ugly' very early on; animals appeared more beautiful and pure to me." Of all the animal symbols he used, the horse was a favorite metaphor for Marc's vision of a world in which mind and matter would be reconciled: "We will no longer paint a forest or a horse in the way they appeal or appear to us, but as they really are, the way a forest or a horse itself feels, its absolute essence, which lives behind appearances" (1912). Marc painted two versions of *Three Horses* in different formats in

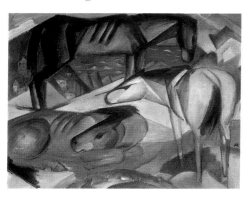

1913. In the left foreground, a red horse rests on the ground, its head resting on its flank. Next to it stands a pale yellow horse, seen from behind, turning to the left. The skinny black mare at the top (based on a carved wooden miniature) forms a barrier before the blue sea, green hills, and pink house gables. Wavering between inward nature and spiritual transcendence, the horses with their archaic colors and elegaic poses evoke a yearning for "redemption from an earthbound existence in this 'vale of tears'," and for an indivisible oneness of being. (A. Hüneke). *RM*

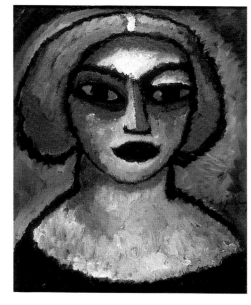

Alexej von Jawlensky (1864–1941)

37 *Head of a Woman* 1912
Oil on cardboard, 61 x 51 cm

Jawlensky, a former Russian army officer and pupil of Ilya Repin, belonged to the inner circle of the Blue Rider. He once described the summer holidays he spent in 1911 with Marianne von Werefkin in Prerow, Pomerania, on the Baltic Sea: "For me, this summer meant a great development in my art. I painted my best landscapes and figurative works there, in very strong, luminous colors, absolutely not naturalistic and corporeal. I used a great deal of red, blue, orange, cadmium yellow, chrome oxide green. The forms were very heavily contoured with Prussian blue, and powerful, out of an inward ecstasy.... In 1912 what I had begun in Prerow developed further." It was that year that marked the emergence of the series of female heads of a strongly simplified, anonymous type, in which Jawlensky continued the "Cloissonism" of Gauguin, the Nabis,

and the Fauves. Dark contours made up of short strokes surround scumbled passages of brilliant color, with a concision aimed at pictorial synthesis. The rounded, voluminous bust is compressed into the almost square format, and the "atavistically fixed gaze," as Armin Zweite notes, is highly compelling. Heavy impasto accents are seen in the yellows of the hair, the reds of the face, and the azure blue of the ground, which, repeated in the eyes, suggests a longing for distant places. The forehead and décolletage shine brilliantly.

The 1912 *Head of a Woman*, which Herwarth Walden exhibited at the "First German Autumn Salon" in Berlin in 1913, is typical of the archetypical portraits Jawlensky painted prior to 1914. Its concentrated, almost barbaric expressionism, derived from a study of primitive art, seeks to penetrate the soul of the sitter, and thus to convey a transcendental meaning. With this style Jawlensky went beyond the decorative arabesques of Fauvism to an "inward vision" that would eventually lead to the constructivist "Abstract Heads" of the 1920s. *RM*

ed type of figure with an Expressionist tendency, prompting the art critic and writer Julius Meier-Graefe to speak of Lehmbruck's "deranged Gothic." The almost Cubistically simplified *Torso of a Girl*, whose averted gaze suggests a tension between sensuous corporeality and inward contemplation, reveals the sculptor's attempt to establish lucid proportions among the parts of a statuesque whole. "All art," Lehmbruck stated, "is proportion. Measure against measure, that is all.... That is why a good sculpture must be treated like a good composition, like a building, where measure works against measure; and that is also why one cannot negate detail, because the detail is the small measure for the large." *FJ*

Wilhelm Lehmbruck (1881–1919)

38 *Torso of a Girl, Turning Around* 1913–14
Stone casting, patinated in red,
98 x 46.5 x 36.5 cm
On loan from a private collection

After attending the School of Arts and Crafts and the Academy in Düsseldorf, where he studied with Carl Janssen, Lehmbruck moved to Paris in 1910, but had to leave the city at the outbreak of the First World War in 1914. His Paris sojourn brought about a change in his sculptural idiom. Influenced in particular by Brancusi, Archipenko, and Modigliani, the softly swelling volumes of Lehmbruck's earlier figures gave way to a more rigorous, tectonic, elongat-

Wilhelm Lehmbruck (1881–1919)

39 *Fallen Man* 1915–16
Bronze, 72 x 82.5 x 239 cm

Fallen Man is one of Lehmbruck's major works — an expression of the horror that struck him in the First World War, which he, unlike many of his contemporaries, considered nothing but a waste of human life. This he had witnessed first-hand, when working as an army medical orderly in 1915.

When this work was shown, under the title *Dying Warrior*, at the 1916 spring exhibition of the "Free Secession" in Berlin, it drew violent, and from some quarters, utterly devastating criticism. The young man is depicted as if just having dropped to

his hands and knees, his forehead resting on the ground. The torso arches like a bridge on the verge of collapsing, the limbs recall supports which cannot hold — a tectonic metaphor for the struggle for survival. While the legs and hips still seem to tremble with energy, the inclined upper body and groping arms, the right hand clutching a broken sword, are already near exhaustion. By means of a seemingly simple physical pose, Lehmbruck succeeds in creating a compelling universal symbol of human anguish and the senselessness of war. *FJ*

attest to extreme and threatening mental stress; the exaggerated volume of the skull suggests an emotional life focused entirely on finding some meaning in existence. The disembodied hand clutching at the chest and the stumps of the arms, like clipped wings, signal a declining physical vitality. Lehmbruck believed that the pressures and strictures evoked here — in what is possibly a self-portrait — are capable of jeopardizing the balance of life, of both body and soul. *FJ*

Wilhelm Lehmbruck (1881–1919)

40 *Head of a Thinker, with Hand*
1918
Stone casting, 62 x 59 x 32 cm

This piece was sculpted in Zurich, where with Max Liebermann's aid Lehmbruck was able to settle in 1917. Despite the peaceful environment, the artist was troubled by memories of carnage and personal problems which led to the first of a series of bouts with depression. The powerful forms of *Head of a Thinker*

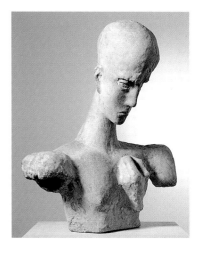

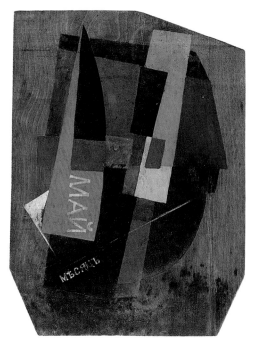

Vladimir Tatlin (1885–1953)

41 *Composition, Month of May*
1916
Tempera, oil, and gouache on panel,
52 x 39 cm

This composition belongs to a series of reliefs of various types done between 1914 and 1920, almost none of which have survived. Tatlin showed the first of what he called "counter-reliefs" in Moscow in 1914 and 1915. These spatial, sculpture-like constructions represented a synthesis of painting, sculpture, and architecture. To color them the artist adopted a technique from icon painting, "levkas," a mixture of fish, bone or casein glue, chalk, and pigment. Influences of French Cubism, and especially Picasso, whom Tatlin visited during his stay in Paris in 1913, combine in his work with elements derived from Russian folk and commercial art, such as shop signs and the bas-reliefs in Orthodox churches. Tatlin's art takes on a distinctly political dimension as well. In 1921 he stated that the revolution had begun in art long before its historical occurrence: "What happened to society in 1917 took place in our visual art in 1914." The understanding and reception of Tatlin's work were marked by misinterpretations even during his lifetime. The Berlin Dadaists, for instance, considered him primarily the founder of a "machine-art" whose forms were supposedly taken straight from the fields of engineering and industry. They extolled him as the protagonist of a movement against an Expressionism grown anemic. At the "First International Dada Fair" in 1920, George Grosz and John Heartfield displayed a banner reading "Art is Dead / Long Live the Machine-Art of Tatlin." Tatlin was perhaps the most important predecessor of Russian Constructivism.

SG

Hannah Höch (1889–1978)

42 *Slice with the Dada Kitchen Knife through the Last Weimar Beer-Belly Cultural Epoch in Germany*
1919
Collage, 114 x 90 cm

Hannah Höch's collage, the largest she ever made, drew special acclaim at the 1920 "First International Dada Fair" in Berlin. Composed of pieces of photographs, headlines, and magazine clippings, it is a kaleidoscope of about fifty highly diverse personalities from the fields of politics and business, the arts and sciences. Rotating ball bearings and cogwheels lend the collage the dynamics of a precipitate silent film. At the upper left appears the physicist Albert Einstein, as a witness to the age, and to his right the "anti-dada

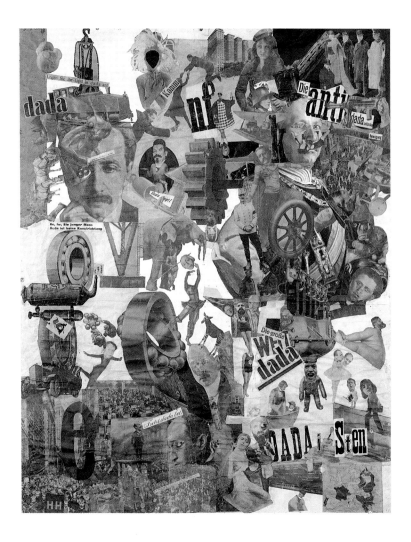

movement" comprising politicians of the Weimar Republic and Wilhelmine Era. Convened beneath them are the major representatives of "World Dada," Raoul Hausmann, John Heartfield, and George Grosz, with Lenin and Marx at their side. The photomontage at the lower left corner juxtaposes mass demonstrations of New York children and German unemployed with a picture of the National Assembly in Weimar.

Slice with the Dada Kitchen Knife points up the conflicts that beset the new Weimar Republic, caricatures the disastrous alliance among the military and big business, the church and the educated middle class. Höch utilized the potentials of the collage technique to create a persiflage of the frenetic activity of a postwar society that seemed to her absurd, and was in fact perched on the abyss.

SG

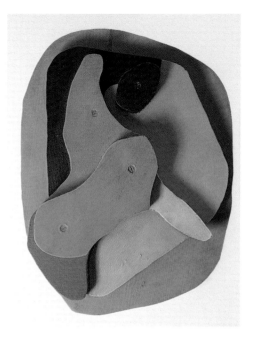

without reference to any particular theme. The reliefs, too, were based largely on the workings of chance. Cutting a number of free-form shapes out of wood, Arp shifted and rearranged them until a pleasing configuration emerged. He had a predilection for organic, biomorphic forms, which, though abstract, retained suggestions of living, natural things, especially plants. These vital, often humorous configurations of the early period do not yet display the aesthetic perfection or self-contained character that mark the later reliefs. Yet they have an undiminished freshness which is just as intriguing as their harmony and simplicity. *BS*

Hans Arp (1886–1966)

43 *Concrete Relief* 1923
Wood, painted, 27.7 x 21.4 x 7 cm

The art produced under the banner of the avant-garde during the 1920s was very diverse, some of it even seemingly mutually antagonistic in nature. Yet despite all the dogmatizing that went on, stylistic borders were astonishingly permeable. Hans Arp, a co-founder of Zurich Dada in 1916, combined the anti-conventional "nonsense" of Dada with a geometric abstraction devoted to the beauty of concrete, non-referential form. Being a native of Alsace, Arp grew up bilingual, speaking both French and German, and his affinity for literature and poetry was just as strong as for painting and sculpture.

Reliefs play a central role in Arp's oeuvre. The catalogue raisonné lists over 800 for the years 1914 to 1922. The principle of chance, a key creative means for the Dada movement, remained crucial to Arp throughout his career. Many collages were seemingly arbitrarily composed of texts, words, and advertising slogans

Kurt Schwitters (1887–1948)

44 *The Broad Schmurchel* 1923
Wood relief, 36 x 56 x 12 cm

Kurt Schwitters (1887–1948)

45 *Cathedral* 1923
Wood relief, 39 x 17 x 7 cm

The Broad Schmurchel and *Cathedral* belong to a series of collages and reliefs which Schwitters began making of diverse, existing materials in 1919, and to which he gave the generic title "Merz-Bilder." The principle on which they were based eventually culminated in a large-scale, walk-in sculpture, the "Merz-Bau," which was destroyed during an air raid on Hanover in 1943 (reconstruction in the Sprengel-Museum, Hanover). Nor have more than a few of the artist's Merz reliefs survived.

In 1946 Schwitters recalled: "In 1923 I spent two weeks with Arp and Hannah Höch in Sellin, where Arp

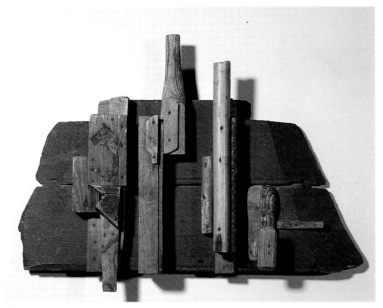

44

and I wrote a poem together. We also made pictures out of pieces of driftwood from the sea." These relief assemblages, which bear an only superficial resemblance to Constructivist objects and the reliefs of Arp (*La trousse du voyageur*, 1922), represent one of Schwitters's most significant contributions to the visual vocabulary of Dada. With great aesthetic sophistication he has arranged pieces of driftwood into plastic configurations which resist referential interpretation and whose often purposely misleading or nonsensical titles reveal them to be, as Werner Schmalenbach says, "altars to absurdity." Nevertheless, the wood reliefs cannot be described merely as ironic reactions, anti-art in the Dadaist sense. For that they are too carefully, rigorously composed, and suffused by a poetic sensibility which respects the intrinsic character of commonplace materials and reveals their charm. *EB*

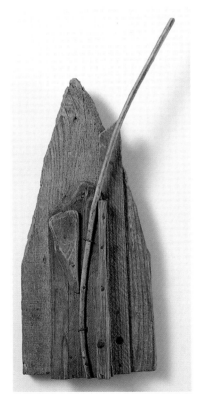

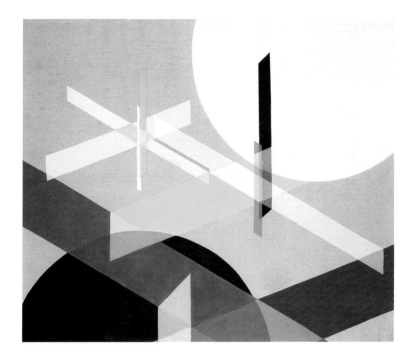

László Moholy-Nagy
(1895–1946)

46 *Composition Z VIII* 1924
Distemper on canvas, 114 x 132 cm

Two ideas dear to the Romantic era — a synthesis of all the arts and an architecture built entirely of glass — were taken up and developed for the new age by the Bauhaus, founded in 1919 in Weimar. The teachers there included Hungarian artist Moholy-Nagy, who, inspired by Paul Scheerbart and the utopian designs of a group of architects including Bruno Taut, began a series of paintings based on the letter Z. They evoked an imaginary, crystalline architecture, within a frame of reference provided by geometric elements in counterpointed hues of yellow and red, white and black. *Composition Z VIII*, from the end of the series in 1924, is a model case. To K. Passuth it representd "a synthesis of his own glass architecture period.... The black double axis in the huge white circular segment indicates, like an admonitory exclamation mark, the crystalli-

zation point of the composition." In his 1929 Bauhaus book *From Material to Architecture*, Moholy-Nagy wrote: "By means of reflection and reflex the surroundings penetrate into the pictorial plane — the flatness striven for since impressionism is dissolved — overcoming the plane not toward plasticity but toward space." *RM*

Lyonel Feininger (1871–1956)

47 *Yellow Village Church I* 1927
Oil on canvas, 80 x 100 cm
On loan from a private collection

Lyonel Feininger, an American whose parents were of German origin, lived in Berlin from 1888 onwards. In 1919 he accepted Walter Gropius's offer of a post as master of the printing shop at the Bauhaus in Weimar. After the move to Dessau, Feininger developed his static "prismatic" approach (see no. 48: *Teltow II*, 1918) into a more flexible, if rigorously planar and crystalline, style. In his lost 1927 painting of the *Yellow Village Church*, the color yellow

symbolizes the sun, a source of illumination outside the picture, which pervades the atmosphere and irradiates every surface, seemingly rendering solid matter transparent. It represents "plane and form conceived in terms of color." (Feininger, 1927). *RM*

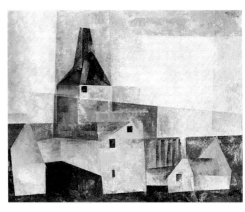

Lyonel Feininger
(1871–1956)

48 *Teltow II* 1918
Oil on canvas, 101 x 125 cm

In 1910 Feininger made his first excursion from Berlin-Zehlendorf to the nearby farming community of Teltow. His trips resulted in numerous "nature notes," later used as the basis for etchings. The first, Futurist, version of the painting, from 1912 (since lost) was shown at the "First German Autumn Salon" in 1913, where Feininger made contact with the Blue Rider group. This second version of the subject was painted during the depression of the final year of the war, in 1918. Rising over the village rooftops is the spire of St. Andreas's church, an originally Gothic structure that was reconstructed according to plans by K. F. Schinkel. Breathing the spirit of Schinkel's "heavenward striving" neo-Gothic style and Bach's fugues, the image is like a prismatic monument to tranquillity and contemplation, an urbane icon partaking both of classicism and romanticism, of reality and dream. *RM*

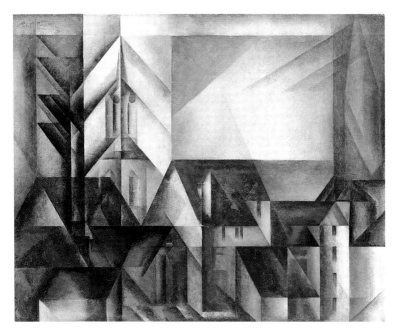

Paul Klee (1879–1940)

49 *Departure of the Ships* 1927
Oil and india ink on canvas,
50.2 x 64.4 cm

Swiss artist Paul Klee, initially associated with *Der Blaue Reiter*, was a master at the Weimar and Dessau Bauhaus from 1920 to 1931. Like his fellow-teacher, Feininger, he was immersed in the Romantic tradition and painted great numbers of marine subjects: *Departure of the Ships, Night Over the Sea, Here — Now,* and *Always — Everywhere.* Here Klee depicts four sailing vessels, composed of triangular shapes in orange, ocher, and browns, as they leave harbor. A red arrow, a space-time vector, points them the way, which seems to lead from present to future, from the concrete to the universal. Suspended over an invisible horizon in the obscurity is a dark moon, its dim light reflected in the schematic bluish waves at the lower right. The ship serves as a symbol of life and the cycle of departure and return. In his essay "Creative Confession" of 1918–20, Klee writes: "And now — what a modern man experi-

ences as he strides along the deck of a steamer: 1) his own motion; 2) the motion of the ship, which can be in the opposite direction; 3) the direction of motion and velocity of the current; 4) the rotation of the earth; 5) its orbit; 6) the orbits of moons and planets all around. Result: a system of motions in outer space, with the 'I' on the ship as its center." *RM*

Paul Klee (1879–1940)

50 *Architecture* 1923
Oil on cardboard, 58 x 39 cm

A musician as well as a painter, as early as 1910 Klee concerned himself with the analogy between colors and tones and with depicting polyphony in visual terms. In 1914, in the Tunesian watercolors, he began employing his "sounding" colors in a compositional framework of squares and rectangles. The resulting virtual movement of the hues, the way they seem to advance out of the picture or recede into it, became a central topic of the lectures on visual form Klee gave at the Bauhaus from 1922 to 1924. His *Architecture —*

Yellow-Violet Graded Cubes represents a "section through the poles" of the six-part color wheel he taught. All the color gradations in the painting were produced by mixing yellow and violet in varying proportions, in some cases with the addition of the non-colors black and white. Yellow cut with black, as Klee noted, loses its color character "towards a green."

Subsequently, when he integrated the light-dark contrasts of white and black in his "Magic Squares" of 1923, Klee took the step from the planar surface to a vibrant virtual architecture in space, conceived synaesthetically as a "musical scale." *RM*

Paul Klee (1879–1940)

51 *From in Motion to Stationary* 1932
Watercolor, india ink, and pencil on cotton, 33 x 88.2 cm
(original frame)
On loan from a private collection

In this picture, painted while Klee was a teacher at the Düsseldorf Academy, elements suggesting motion, such as triangles, arrows, and rhombuses, interrupt stationary horizontal lines and flat planes. The impression of motion through space and time results from the coexistence of opposites — calm and agitation, activity and passivity, motion and immobility — within a formal structure based on earthy, nearly monochrome, hues. The extended horizontal composition uses the device of the stage flat: a juxtaposition and superimposition of plane surfaces, their interpenetration and overlapping to translate the idea of "landscape" into tectonic terms. *RM*

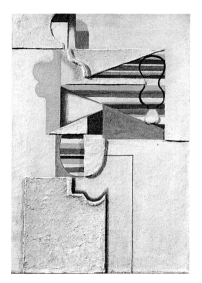

The year 1920 marked a turning point in Baumeister's style, from subjective expression to an objective, constructivist design. To quote the artist: "In the most intimate relation to the tectonic and utilitarian factors of architecture, to space and negative space, to the wall surface, to the masses and proportions employed, the wall painting evolves into artistic conclusions" (1925–26). Baumeister's "Wall Paintings" correspond with the Bauhaus idea of a synthesis of all the arts, as the dedication on the reverse of *Figure with Stripes* indicates: "To Walter Gropius," the artist writes, and adds their shared maxim, "Art is craft." *RM*

Willi Baumeister (1889–1955)

52 *Figure with Stripes* 1920
Plaster, papier maché, putty, and oil on canvas, 72.5 x 52.5 cm

Baumeister's early style was influenced by Cézanne and the French Cubists. While a master student at the Stuttgart Academy in 1919, he broke with the tradition of the framed easel painting to create his first architecture-related works, which he called "Wall Paintings." *Figure with Stripes*, of which several variations were made, is a case in point (see also no. 53: Schlemmer, *Relief JG*, 1919), which evinces a sculptural approach to painting that blends painting with relief and architectural elements. The work is dominated by banded geometrical forms, triangles, arc segments, and rectangles, arranged in parallel planes within a framework of structural relief. Figurative references, such as to a female figure with breasts, seen frontally and in profile, are subordinated to the general, abstract, non-illusionistic scheme. The effect of the image derives from the contrast between smooth and textured surfaces, color and absence of color, flatness and relief projections.

Oskar Schlemmer (1888–1943)

53 *Relief JG* 1919
Plaster, painted in oils, 67.5 x 33 cm (original painted wooden frame: 88 x 50 cm)

On April 27, 1915, Schlemmer noted in his war diary: "I extend my hand to the idealists of form. To Lehmbruck and Archipenko in sculpture, and to the Cubists in painting. They provide a transition to the art of building by building in their art." Concurrently with Willi Baumeister, his friend and fellow-student at the Stuttgart Academy (see no. 52: *Figure with Stripes*, 1920), Schlemmer developed an architecturally-oriented, sculptural painting. On the strength of it he was offered, in 1921, a teaching post in mural painting and wood and stone sculpture at the Bauhaus. In *Relief JG*, of which three polychrome variants exist, various plaster relief components — a schematized hand and leg, segments of circles and squares — are arranged along the vertical axis of an upright rectangular plate. One can detect the human figure on which the geometric scheme is based. The initials of the title, "JG," refer not to any person but to key shapes in the composition — the "J" to the contour of the leg,

the "G" to the semicircle at the center. The contrast between warm and cool hues in the relief and on the frame, as well as the modeling in light and shadow ("Light must come from the upper left," Schlemmer noted on the reverse), emphasize the idol-like tranquillity and composure of the figure. This archaic "tablet of the law" was the point of departure for the relief variations Schlemmer executed in private and public architectural spaces during the 1920s.

RM

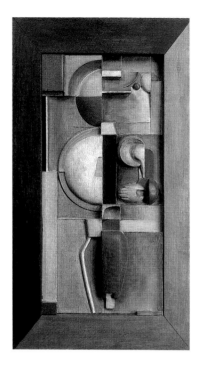

Oskar Schlemmer (1888–1943)

54 *White Youth* 1930
Oil on canvas, 60 x 45.5 cm

To Schlemmer, as to the artists of the Renaissance, man was the measure of all things. In a letter of January 31, 1930, he wrote: "'Space and Man' is the fundamental theme, big enough to really thrill one to the marrow." His painting of an adolescent boy in white, seated on a round-backed chair and turning his head in profile, was done in Breslau in 1930. It is a good example of Schlemmer's "contour figures": linear, geometric figures developed out of a preceding series of drawings and lithographs. The almost mechanical rigor of the torso is softened by the organically rounded shapes of the hair, chair back, and schematic hands. These contrasts are brought together by a palette of finely gradated hues of terra di siena and grayish black, heightened by glazes that increase the impression of a space suffused with light. The matte white priming of the canvas sets off the warm glow of the boy's face, which is echoed by the reddish brown wood of the chair back.

Completed on February 12, 1930, *White Youth* is a picture in light hues that relate it to Schlemmer's murals for the Folkwang Museum in Essen. The meditative character of the simplified and idealized individual fig-

ure sets a counterpoint to the compositions of several statuesque figures of the early 1930s. Schlemmer, the "idealist of form," who veritably constructed his pictures, had reached his goal: "Metaphysical perspective, metaphysical figure."

RM

Max Liebermann (1847–1935)

55 *Self-Portrait* 1925
Oil on canvas, 112 x 89 cm

Self-portraits occur throughout
Liebermann's oeuvre. They marked
the beginning of his portrait activity,
and led directly to commissions to
portray famous contemporaries. At
Ludwig Justi's behest, his self-portrait
of 1925 was acquired for the Natio-
nalgalerie by the Ministry of Culture
that same year, for display at the
Kronprinzenpalais. Liebermann,
seventy-eight, and president of the
Prussian Academy of Arts depicted
himself in the studio, seated before
a canvas, with brush and palette
in hand. Like his idol Rembrandt,
Liebermann often employed a warm,
brownish palette in his later work,
and depicted himself *en face* with
a cap or hat (preliminary drawing,
Kupferstichkabinett, Berlin). Careful
observation in the mirror, the loose,
fluent brushwork, and the relaxed,
unforced pose reflect his artistic rela-
tionship to nature, seeking the spiri-
tual through an exploration of the
visual. *FW*

Lovis Corinth
(1858–1925)

56 Schlossfreiheit,
Berlin 1923
Oil on canvas, 104 x 79 cm

"Yesterday I varnished
'Palace Precincts,' which
you ... painted from the
window of the Darm-
städter Bank," wrote
Charlotte Berend-Corinth
to her husband. "All the
deep, profound blacks
came out, the stone wall
took on fine nuances, and
on the green dome ... [a]
tumult of brushstrokes." It
was apparently a stormy
day when he painted the
Baroque west facade of
Berlin Palace, for though
his palette is subdued,
the impasto brushwork
is all the more agitated and vibrant.
Liebermann's successor to the chair
of the Berlin Secession was not espe-
cially interested in cityscapes. Yet the
exuberant forms of Eosander's portal,
Stüler's dome, and Begas's Kaiser
Wilhelm Monument evidently in-
trigued him for the chance they offer-
ed to capture the pulsating life of the
metropolis in a historical setting.
FW

Lovis Corinth (1858–1925)

57 *The Trojan Horse* 1924
Oil on canvas, 105 x 135 cm

Praised by Ludwig Justi as Corinth's most beautiful picture, *The Trojan Horse* was painted in the artist's Berlin studio a year before his death. It holds an outstanding position in his late work, which is remarkable for its expressive, sensuous, and sumptuous color. Subjects from antiquity had always challenged the artist to evoke profane and parodistic figures, as in the sequence of Odysseus paintings begun in 1903, or *The Childhood of Zeus* of 1905.

It is not so much the staging of the scene, with its traditional focus on the all-important horse, as the painterly handling of it that marks Corinth's composition as special. As Homer relates, the Greeks owed their victory over Troy to Odysseus's idea of smuggling warriors into the fortified city by concealing them in the belly of a great wooden horse. Abandoning some ships to create the impression they had withdrawn, the Hellenes left only one man behind to trick the enemy into taking the horse

in, and to report his success with a signal fire. The events of that misty morning, when the Trojans streamed out of their gates and took the narrator prisoner, have been placed by Corinth in the middle ground of the picture, increasing the sense of atmosphere and space. In the midst of the scene and towering above the soldiers stands the colossus, ominously facing the walls of Troy. The myth is given a scurrilous touch by the rear view of the rather leathery-looking steed, the clumsiness of the advancing Trojans, and the resemblance of the Greek ships to Berlin's Spree River barges. Yet over the entire pictorial space is a film of enigmatically shimmering color, a field of flickering sparks beneath which the real world seems to recede and vanish. As if seen through a veil, the events depicted seem strangely alienated, for as Siegfried Gohr says: "The myth is dissolved in a vision of color." Freedom, both aesthetic and intellectual, eminently characterizes the late works of Corinth. *FW*

Ludwig Meidner (1884–1966)

58 *Revolution (Fighting on the Barricades)* 1912–13
Oil on canvas, 80 x 116 cm

Painter-poet Ludwig Meidner, born in Silesia, moved in 1905 to Berlin, where he founded an artists' group called *Die Pathetiker* (The Exponents of Pathos) in 1912. It was late that year and into the next that he recorded his premonition of revolution on the streets of Berlin. Looming in the center, a standard-bearer with a red sash, wounded, cries out as if to encourage his comrades not to lose heart. The street behind him is a tremendous uproar of rifle fire, exploding grenades, buildings burning and collapsing. Meidner has portrayed himself as well, as the wide-eyed, anxious onlooker in the lower left corner. The strident hues of the banner recall the tricolor in Delacroix's *Liberty Leading the People* of 1830. Depicted on the reverse of *Revolution* is a male figure — variously interpreted as representing Adam, Christ, or the "noble savage" —

asleep in the midst of an apocalyptic landscape. The back-to-back scenes embody the dual thrust of Meidner's Expressionism: the moloch of the big city on the one side, and on the other a call to revolt against the ossified society of Wilhelmine Germany, painted years before the World War and the November revolution of 1918. In his *An Introduction to Painting Big Cities*, written in 1913, Meidner paved the way for the expressive realism of a Dix or Felixmüller in the 1920s: "Let us paint what is close to us, our urban world! The tumultuous streets, the grace of iron suspension bridges, the gas tanks hanging in white mountains of clouds, the garish colors of the omnibuses and express-train locomotives, the rising and falling telephone wires (are they not like singing?), the harlequinades of poster pillars, and then the night ... the metropolitan night.... Wouldn't the drama of a well-painted factory smokestack move us more deeply than all the Gorgon fires and Constantine's battles of a Raphael?"

RM

Otto Dix (1891–1969)

59 *Moon Woman* 1919
Oil on canvas,
120.5 x 100.5 cm
(original painted wooden
frame)

A war veteran become a master student at the Dresden Academy, Dix painted this vision of a woman composed of crystalline spheres, hovering in space over a glittering city. As the clocks indicate, the final hour has come for this moon-mythical articulated doll, as a red rooster proclaims the approaching dawn. *Moon Woman* is one of a series of four paintings of 1919 (*Resurrection of the Flesh*, *Leda and the Swan*, *Pregnant Woman*), which, as Fritz Löffler says, "underscore the elemental event of sex in all its limitlessness." With his ironic homage to the stargazing lyricism of Paul Klee and Theodor Däubler, "DIXdada" pokes fun at the cosmic raptures of the late Expressionist *zeitgeist*. *RM*

concentrated profile as he wields the brush like a hatchet. The painting of a seminude prostitute Dix is working on was later lost without a trace. It alludes to the life-sized doll with the features of Alma Mahler, which Oskar Kokoschka commissioned in Dresden in 1919 (depicted in his *Man with Doll*, 1920–22). *RM*

Conrad Felixmüller
(1897–1977)

60 *Otto Dix Painting* 1920
Oil on canvas,
120.5 x 95.5 cm

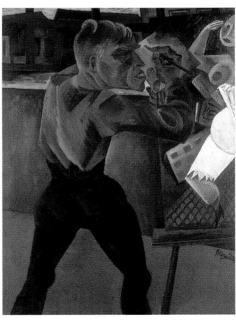

After the war Conrad Felixmüller encouraged his friend, Dix, to join the late Expressionist "Dresden Secession Group 1919," and mutual portraits ensued. The present oil was preceded by an etching, representing Otto Dix drawing. Dix's own description of himself as a "berserker" is wonderfully captured in the powerful, angular figure and tensely

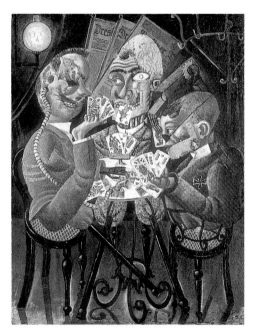

At the same time Dix seems fascinated by these men's will to survive, the way they seem to enjoy what little of life is left to them, a bizarre card game and amorous fantasies. The painter has even included himself in the picture, in the photo pasted into the artificial jaw of the figure on the right, which is inscribed "Lower jaw, Dix brand. Genuine only with portrait of inventor."

The devices of the Dadaist grotesque — painted and collaged playing cards, newspapers, aluminum foil, paper imitations of textiles — are used to point up the absurdity of the postwar period, as embodied in men whom war has reduced to mere half-men, social outcasts, shockingly exhibited as if in a peep show. The image (which also appears in reverse in a drypoint) is the most macabre of the four depictions of disabled veterans Dix made in spring 1920 (the other three are: *Match Vendor I*, Staatsgalerie Stuttgart; *Prague Street*, Galerie der Stadt Stuttgart; *45% Employable*, destroyed as "degenerate" by the Nazis in 1939). With this antiwar painting of an anachronistic and unjust society as seen in a distorting mirror, Dix took the step to the critical verism of his 1920s style. In his own words: "I discovered in 1918 I could do it all. I only needed to throw it out. The Expressionists were making art enough. We wanted to see things stripped naked, to see clearly, almost without art."

The Skat Players was acquired in 1995 thanks to an unprecedented fundraising campaign on the part of the "Verein der Freunde der Nationalgalerie," supplemented by funds from the German Lottery and donations from numerous art-lovers. RM

Otto Dix (1891–1969)

61 *The Skat Players* 1920
Oil and collage on canvas, 110 x 87 cm

This painting was executed in Dresden, in early May 1920, after Dix had seen disabled veterans playing cards in a coffee shop (preparatory drawing, private collection, New York). According to the artist's inscription on the reverse, the men belong to a card club of former 342nd Regiment officers. The nocturnal scene is set as if on a lighted stage. They hold their cards — from a deck known as the "Saxon Double" — with their hands, feet, mouth, and artificial limbs. Behind them, actual sections of Dresden and Berlin newspapers pasted to the canvas allude to current events and circumstances: the Kapp Putsch, the status of the military caste, and a demand that the "disgrace of Versailles" be avenged. The men symbolize the tenacious hold that imperial German militarism still had on the Weimar Republic, its arrogance and brutality, hero-worship and unthinking patriotism, and above all its self-destructive tendencies.

George Grosz
(1893–1959)

62 *Pillars of Society*
1926
Oil on canvas, 200 x 108 cm

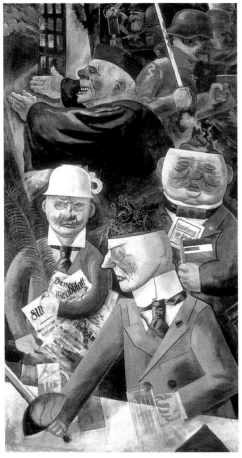

George Grosz and Otto Dix had known each other since their student days in Dresden prior to 1914, and after the "First International Dada Fair," held in Berlin in 1920, they became close friends. During the "roaring twenties" their provocative, socio-critical realism put them in the spotlight of public attention. The title of Grosz's large canvas ironically alludes to Ibsen's play of the same name. In this case the "pillars of society" are Grosz's typecast representatives of official hierarchy in the Weimar Republic. In front is a lawyer who has no ears to hear but an impressive monocle and a stiff collar. His scarred face, beer mug, and fencing foil mark him as an alumnus of a duelling fraternity, the swastika tie pin and phantom horseman emerging from his skull reveal him to be a former cavalry officer, incorrigibly dreaming of recapturing Germany's eastern provinces. The journalist with the features of press czar Alfred Hugenberg, alias The Spider, has a chamber pot on his head to suggest his limited mental capacity, and his dailies, *Berliner Lokal-Anzeiger* and *8 Uhr Abendblatt*, under his arm. The third figure, a member of parliament leaning on the Reichstag, grasps a flag of the German National Party and the slogan "Socialism is Labor." The contents of his cranium illustrate a scatological German phrase meaning "Keep the pot boiling." The military chaplain, who obviously likes his drink, represents the general staff, sanctimoniously preaching peace while condoning the brutalities of the Reichswehr, Stahlhelm, and Wehrwolf troops behind him. In the background buildings burn; not yet synagogues. The composition is based on the drawing *We Come to Pray before God the Just* of 1920–21. Having worked in graphic techniques for years, in 1926 Grosz turned to oils to sum up his critical, moralizing art in what amounts to modern history painting. *Pillars of Society* was likely intended as the right wing of an unfinished triptych (the middle panel, *Eclipse of the Sun*, is in the Heckscher Museum of Art, Huntington, N.Y.). *RM*

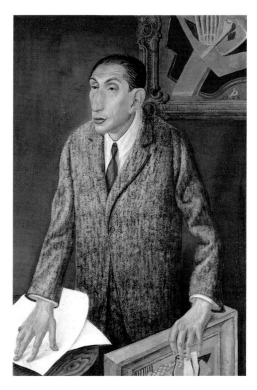

Otto Dix (1891–1969)

63 *The Art Dealer Alfred Flecht-heim* 1926
Oil on panel, 120 x 80 cm

After establishing galleries in Düsseldorf, Frankfurt, and Cologne, Flechtheim opened one in Berlin in 1922, where he published the arts and cultural journal *Der Querschnitt*. At his premises at 13, Lützow-Ufer he showed primarily modern French art, from Matisse to the Cubists, but also German artists such as George Grosz and Max Beckmann, and the Swiss-born Paul Klee. Otto Dix had known Flechtheim from his Düsseldorf period, but it was not until 1926, in Berlin, that he portrayed him. Dix, who considered the art dealer "decadent and avaricious," shows him standing in his gallery salesroom, apparently gazing at a potential client outside the picture. Flecht-

heim's right hand rests on drawings by Picasso on the table, his left on an oil by Braque; partially visible behind him on the wall is a Cubist painting by Juan Gris, which Dix has self-confidently monogrammed with his "D" and dated 1926 — verism versus abstraction. Dix emphasizes the cunning look of the dealer with a "nose for trends" to the verge of caricature, but ultimately the portrayal is so many-sided and psychologically penetrating that it stands as a masterpiece in the artist's series of Berlin portraits. As he recalled in 1965: "The first impression one has of a person is also the correct one.... I worked for about three weeks on a portrait like this.... Usually I made a precise drawing after the sitter, then, when it had been transferred to canvas, came the underpainting, also after the sitter. Only then did the real work start — painting without the model." It can be inferred from the portrait that artist and sitter had no great sympathy for one another; in fact their opinions about art strongly diverged. In 1924 Karl Nierendorf, Dix's Berlin dealer, fueled the fire by informing him that "Flechtheim is slandering you again, calling you a 'fart painter' & telling everybody your paintings stink. He praises his Frenchmen to the skies & always cites you as their German antithesis."

Through his gallery and publishing activities, Alfred Flechtheim did much to further an appreciation of modern art in Germany. Being Jewish, he was forced to flee his native country in 1933, and died in exile in London, in 1937. *RM*

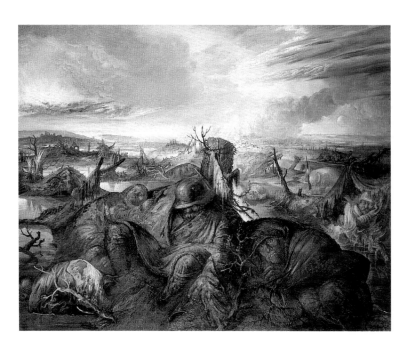

Otto Dix (1891–1969)

64 *Flanders* 1934–36
Mixed media on canvas, 200 x 250 cm

Driven by the Nazis from his teaching post at the Dresden Academy in 1933, Dix worked from 1934 to 1936 at Randegg Castle on Lake Constance, where his last great war painting, *Flanders*, was executed. The historical point of departure was the trench warfare in Flanders in the late summer of 1918, in which Dix himself was involved. Yet his picture, painted from memory rather than from his eye-witness sketches, has the nature of a vision, and takes up visual metaphors of the kind found in antiwar literature of the day: Erich Maria Remarque's *All Quiet on the Western Front*, and Henri Barbusse's *Le feu*. In his chapter "Dawn," Barbusse writes: "An enormous silence. Not a sound…. Nobody is firing…. No shells coming over … the men, where are the men? Gradually they appear to view. Not far from us lie a few on the ground, asleep. Covered in mud from head to foot…. A little farther on I see more soldiers; they are cowered down, sticking like snails to the round hill, which has been half absorbed by the water … and they are the same color as the earth…. Are they Germans or French?… Are they dead? Asleep? You cannot tell. Everything is over now. It is the hour of immense rest, the epic interval of war."

The landscape of *Flanders* extends to the distant horizon, plowed by trenches and shells as if in the wake of the Deluge. The men sunk in the mud of the shell-holes exist on the borderline between exhaustion, sleep, and death, watched over by cold and ominous sun and moon — an apocalyptic landscape that spans the life of mankind from dawn to doom. Stormy skies loom threateningly on the horizon, a premonition of the Second World War, which would begin just three years after the painting was finished.

In the final months of the Second World War, Dix was inducted into the Volkssturm, and subsequently taken prisoner by the French. In February 1946 he returned to Hemmenhofen on Lake Constance. *RM*

Giorgio de Chirico (1888–1978)

65 *The Great Metaphysician*
1924–26
Oil on canvas, 110 x 80 cm

Impressed by the symbolic landscapes of Arnold Böcklin and by Nietzsche's descriptions of the squares of Turin, de Chirico discovered the melancholy of the empty Piazze d'Italia in Ferrara, "the most metaphysical of all cities," between 1913 and 1917. This is terra incognita — a plaza in the harsh afternoon sun, devoid of life, flanked by Renaissance arcades like stage flats, on the horizon a chain of low hills punctuated by a factory chimney and overhung by a night sky. A harsh cast shadow falls upon the monument to the great metaphysician, erected on a wooden pedestal. Like some absurd trophy, it is a congeries of bits and pieces of discarded things: a geometrician's tools and old cabinets, capped by the bust of a display-window mannequin — a symbol of the treatment of humans as objects, but also an ironic commentary on the hero worship of the nineteenth century. With his *Great Metaphysician* (predated to 1916; first version, of 1917, in The Museum of Modern Art, New York) and the *pittura metafisica* co-founded by him and Carlo Carrà, de Chirico called attention to the enigmatic and ambiguous nature of the world and man's place in it, and provided impulses for the Surrealists Max Ernst, Salvador Dalí, and René Magritte. *RM*

René Magritte (1898–1967)

66 *L'idée fixe* 1928
Oil on canvas, 81 x 115 cm

Black crossbars suggest a window with four equally sized panes, or picture planes, each depicting a different, carefully rendered image: an impenetrable hardwood forest, a cloudy sky, a section of a forbidding brick facade, and a man with a gun crouching in anticipation in front of a wall. Nature, man, and architecture are

set in counterpoint to one another, in an alternating light-dark rhythm. The illogical sequence of these otherwise lucid images lends them an ambiguous, traumatic context of "meaning." Magritte invents borderline situations which, in their arbitrariness, point up the basically mysterious nature of life itself. The man with the gun — is he a murderer or a hunter? Wieland Schmied answers: "He is hunter and hunted, culprit and victim in one, doing violence and exposed to monstrous impressions." This adventurer and the artist himself are one and the same person. His hallucinatory canvas (also produced in a film version, before 1932, since destroyed) was painted in 1928, when Magritte was part of the Paris Surrealist circle around André Breton. *RM*

Salvador Dalí (1904–1989)

67 *Portrait of Mrs. Isabel Styler-Tas (Melancolia)* 1945
Oil on canvas, 65.5 x 86 cm

Catalonian artist Dalí joined the Paris Surrealist group in 1929. In 1936, after the outbreak of the Spanish

Civil War, he moved to Italy, then in 1939 to the United States. His portrait of the daughter of Louis Tas, a gem dealer from Amsterdam, was done on commission in Beverly Hills in 1945. The haughty heiress, wearing a Medusa brooch, gazes stonily past a petrified version of herself, a wooded cliff, in the midst of a flat, fantastic landscape. This is a good example of what Dalí called his "critical-paranoic" portraits, in which he paraphrased the compilatory style of Arcimboldo and the Renaissance portraits of Piero della Francesca (*Federigo da Montefeltre*, ca. 1465; Uffici, Florence). In the periodical *Dalí News*, dated for November 20, 1945, the artist explained that in portraiture it was his intention to establish a relationship of fate between the person depicted and his or her background, in a way that — far from direct symbolism — summed up the "mediumistic and iconographical" content which each sitter triggered in his mind. *RM*

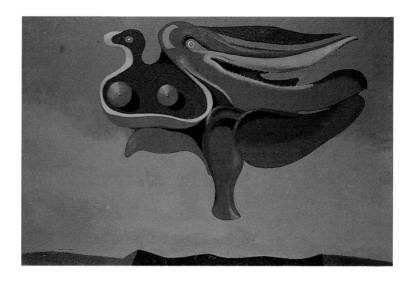

Max Ernst (1891–1976)

68 *The Evil Elect* 1928
Oil on canvas, 230 x 300 cm

"I believe in the future resolution of these apparently so contrary states of dream and reality, in a kind of absolute reality, or, as one might say: surreality," averred André Breton in his 1924 "Surrealist Manifesto." It was a German artist, from the Rhineland, who found visual correspondences for the French intellectual's ideas. Using automatic techniques, such as frottage and grattage, and a conscious combination of disparate elements, Max Ernst created a phantasmagorical new reality. A series entitled "Monuments to the Birds," painted in 1927, led the following year to the grandiose and demonic *L'élue du mal* (a smaller version is now in the Kunstmuseum, Basel), whose title alludes to Charles Baudelaire's *Les Fleurs du mal. The Evil Elect* is a chimera, a two-headed hybrid of a female bird with metal breasts and an antediluvian legendary beast, winging over a mountainous desert landscape. Its eyes glitter cold as stars, an intense mysterious red shines along its skull, at the tip of the tongue emerging between crocodile teeth, finally to be concentrated like a burning signal-lamp in the distant moon. The ominous green creature symbolizes hubris — the greed for life and the insatiable desire for evil. Subsequently, in his series devoted to "Loplop" (head of the birds), Max Ernst would produce variations on the mythical creature that included an aspect of ironic self-portrayal. *RM*

Max Ernst (1891–1976)

69 *Capricorn* 1948–64
Plaster, tinted, 247 x 210 x 155 cm

Max Ernst left the Paris Surrealist group in 1938, and emigrated to the United States in 1941. In 1946 he turned his back on sophisticated New York to settle in Sedona, Arizona. It was there, in a primeval landscape of red-rock mesas and canyons, that *Capricorn* was conceived of. It is a monumental outdoor sculpture made in part by applying cement to various mundane objects, such as automobile springs (horns, necks, fishtail) and stacked milk bottles (scepter). In 1954 Ernst left Sedona to settle in France. Upon returning to Sedona in 1963 he made a plaster

mold of the cement sculpture (which was later destroyed), which in turn was reworked and revised the following year for the purpose of bronze casting.

The title, "Capricorn," refers to the tenth sign of the zodiac. In Babylonian and Greek mythology, the wild goat, or ibex, was a symbol of fertility and rebirth. Ernst's frontally severe group, reminiscent of the cult figures of Asia Minor, consists of two grotesque seated figures. The ram-headed ruler is enthroned like some astral sea-god, grasping a scepter and an imperial orb in the form of a figure — half infant, half fish; a water spout emerges from his lap (the seat).

Seated at his side is a slender female figure with attributes of a goat and mermaid, a fish symbol and a solar halo gracing her head. A "mythical antitype to the lonely pathos of the landscape" of Arizona, as Werner Haftmann describes it, *Capricorn* combines animal and emblematic aspects of the zodiac cult, while at the same time ironically commenting on contemporary worship of royalty. It is an "encyclopedic sculpture," says Werner Spies, that recapitulates all the key motifs of Ernst's sculptural oeuvre. The plaster model and a bronze casting were presented by the artist to the Nationalgalerie.

RM

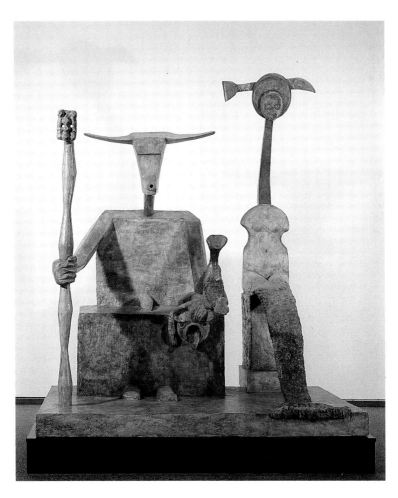

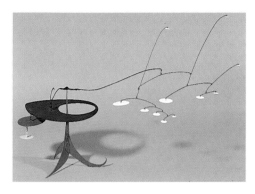

Alexander Calder (1898–1976)

70 *Dancing Stars* ca. 1940
Standing mobile: painted sheet metal
and wire, 60 x approx. 90 cm

In 1927 American sculptor Alexander Calder exhibited figures, portraits, and animals formed of wire in Paris. These marked the beginning of a development — encouraged by his artist-friends Hans Arp and Joan Miró — that culminated in the early 1930s in Calder's famous "mobiles." These metal constructions, now entirely abstract, were carefully balanced configurations of thin iron wire and light shapes made out of sheet metal and painted in various colors, which were set in motion by the slightest breath of air. The result was a surprising, hovering interplay of forms that recalled leaves trembling in the wind, the flapping of birds' wings, or even the rhythms of a dance. As in *Dancing Stars*, Calder counterposed heavy elements on one side against lighter ones, mounted on branching wires, on the other, emphasizing the different mobility of the elements in a way that evokes not only the natural environment but the vicissitudes of human life. In retrospect Calder stated, in 1967, that he believed from that point on, and practically ever since, that the system of the universe or a part of that system became the deeper meaning of all the forms in his work.

FJ

Joan Miró (1893–1983)

71 *The Little Blond in the Park of Attractions* 1950
Oil on canvas, 65 x 92.5 cm

"For me, Miró was the quintessence of liberty. Something more airy, relaxed, lighter than anything I had ever seen," said Alberto Giacometti, who, like Miró, belonged to the Surrealist group in Paris in the 1920s. For Miró, who until then had been working in a semiabstract, Cubist-influenced style, the association with writers and artists like André Breton, Max Ernst, and Hans Arp, and their emphasis on unconscious and irrational processes, helped to release his innate tendency towards poetic form and fable. An abundance of playfully primeval, sophisticatedly naive forms spreads across the shallow space of Miró's canvases, evoking insouciant life played out in a weightless realm. Abstraction and meaning, archaic symbols and concrete references enter into an imaginative interplay. As seen in *The Little Blond*, Miró loves to toy with transformations, with the funny and the bizarre, yet behind the

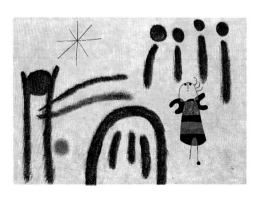

smile is a touch of the demonic. The little girl standing in the sunny park seems threatened by the dark, shadowy, heavy forms emerging around her, though she still has enough space to escape, if need be. "What I search for," said Miró, "is a motionless movement, something equivalent to what is known as eloquent silence, or what St. Juan de la Cruz describes by the term silent music."

FJ

Constantin Brancusi (1876–1957)

72 *Bird* ca. 1940
Bronze, polished, on marble plinth and sandstone pedestal; total height 258 cm, height of sculpture 135 x 10.5 x 17 cm

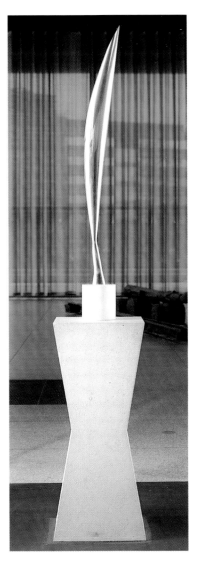

Constantin Brancusi was born into a peasant family in rural Romania. He first learned the cabinetmaking trade before beginning his studies in sculpture in 1898, in Bucharest. After two years of traveling he went in 1904 to Paris, where he remained to the end of his life.

Brancusi made a crucial contribution to the development of modern sculpture in this century. He doggedly devoted himself to a fundamental form that was reduced to essentials, self-contained, and organic in source. The egg-shape with its dynamic tension and plastic quality became for Brancusi a kind of primeval form, from which he developed many of his serenely balanced, precisely designed works. Brancusi looked upon this simple form both as the symbolic quintessence of emergent life and as an expression of the highest perfection. Its plastic qualities take on a meditative aspect, representing the poles of an inner, self-contained fullness and the penetration of external space. Particularly the motif of a bird in space, to which Brancusi devoted twenty-eight variations, has an upward-striving, elongated configuration and polished surface that make it seem almost immaterial, and transform it into a symbol of energy-charged weightlessness.

FJ

Wifredo Lam (1902–1982)

73 *The Marriage* 1947
Oil on canvas, 215 x 197 cm

From his birth in Cuba in 1902 to his death in Paris in 1982, Wifredo Lam remained a wanderer between two worlds. Chinese on his father's side and mulatto on his mother's, the boy was introduced by his black godmother to ritual invocation ceremonies, impressions of which would later bear fruit in his art. Intially, however, Lam's training was in landscape painting in the local tradition, supplemented, when he went to Madrid in 1923, by influences of the European art he saw in the Prado. It was not until his move to Paris and meeting with Picasso and the Surrealists that Lam's own, inimitable

visual idiom began to take shape. He was especially fascinated by the enigmatic character of Picasso's Cubism, in which he immediately recognized the "African look" which would determine his style from that point onwards. A first major work from the period after his return to Cuba in 1942 is *The Jungle* (1942–44; The Museum of Modern Art, New York), in which fetish-like figures are interwoven with sugarcane stalks to form an impenetrable fabric. The composition of *The Marriage* of 1947 seems more lucid by contrast, though its meaning is less immediately decipherable. The palette is strikingly reduced to shades of gray and white, which, like the aggressiveness of the symbolism and the sharp-contoured, dramatically illu-

minated figures, recall Picasso's *Guernica* of 1937. Lam's canvas, too, while not referring to any current event, is a protest against genocide. In terms of both motif and composition, *The Marriage* is a spectacle of sheer destructiveness, invoked by the ominous trappings of black magic.

AS

Roberto Matta (Sebastian Antonio Echaurren; b. 1911)

74 *Earthsick* 1962
Cement, ground fire-clay, and oil on burlap, 200 x 290 cm

In most of Matta's paintings, who was born in Santiago de Chile in 1911, human beings and machines fuse together into self-sufficient, smoothly functioning hybrids which, forever in motion and incessantly mutating, populate the far reaches of outer space. These apocalyptic visions, reminiscent of the more pessimistic type of science fiction, began to emerge in the late 1940s, as the atrocities of the Second World War came to light. Ever since, Matta's work, which was initially shaped by contacts with André Breton's Surrealist circle, has focused on the never-ending terror of this world, and indeed he considers himself a political painter. "Mal de terre," which can be translated as "yearning for the earth" or "earthsick," holds a special place in Matta's oeuvre. The earthy pigments, mixed with sand and clay, and the softened forms combine to produce a less aggressive, more benign impression than that of earlier canvases. The technology-gone-mad bizarreness is toned down, as if these marching, robotlike creatures had reconciled themselves to an earthbound existence. Also, the elongated upright figures point to another source of inspiration which was important to Matta and the Surrealists, all of whom were passionate collectors: the art of Australasia. They were especially intrigued by the narrative qualities of *malanggans*, carved and painted representations of the dead and mythical ancestors in animal or human form.

AS

e delaunay 28

Robert Delaunay (1885–1941)

75 *The Eiffel Tower* 1928
Oil on canvas, 100 x 81 cm

Delaunay's concern with the motif of the Eiffel Tower, which he called "the barometer of his art," began in 1909, and reached an apex in 1910–12. For him, the soaring iron structure, built for the 1889 Paris World Fair, perfectly embodied the modern technological age. In a dynamic, deconstructive style influenced by Futurism, Delaunay eventually distilled his vision into what he termed, in 1924, a "cosmic oscillation," a "synthesis of the entire epoch." By dissolving the solid construction into its components and suffusing it with light, the artist not only evoked the soaring domination of the modern tower over the old Paris quarters but, in a sort of reversed montage process, he celebrated the energy and

effort that went into its construction. The orphic play of light and color of Delaunay's collapsing, sometimes exploding, tower suggests a prophetic vision of a Europe torn asunder by the First World War.

After returning to the motif of the Eiffel Tower in 1922, Delaunay devoted over twenty canvases to it until 1930. In the series of late towers, seen from a bird's-eye view inspired by aerial photographs and, unlike the earlier, fragmented visions of Orphic Cubism, showing the tower solid and whole, the present painting represents the last and the largest in format. With a sobered attitude to modern technology, Delaunay depicts the structure firmly planted in the ornamental landscaping of the Champs de Mars. *EB*

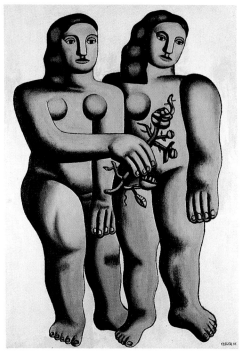

Fernand Léger (1881–1955)

76 *Two Sisters* 1935
Oil on canvas, 162 x 114 cm

The two imposing female figures, in cool grays set off by a lemon-yellow background, have a musing, introspective facial expression that seems in strange contrast with the exaggerated proportions and swelling volumes of their bodies. Despite the suppression of individuality in favor of an abstract, objective ideal, Léger captures the dignity of human existence in a combination of outward monumentality and inward composure. As he himself said in 1952, he strove to understand "the human figure no longer as an emotional value, but solely as a visual one." Léger's definition of the human figure, unlike that of other classically influenced artists, was not derived from the Renaissance. Though his *Two Sisters* of 1935 still relies on the basic principles of his mechanistic, constructivist phase after 1918, the soft, unbroken contouring of the body indicates an incipient detachment from its rigorously geometric approach. The figures of the sisters, who are also related in the more universal sense of shared gender, are repeated almost unchanged in Léger's 1936 canvas *Two Women and Three Objects*. Here, their corporeality, whose organic integration in and parity with nature is symbolized by the conferral of the flower, is established by depicting the three abstract objects in a context free of all hierarchy. *EB*

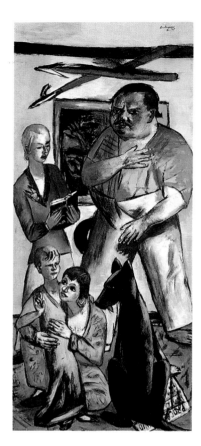

George rehearses his lines; the actor's son, Jan, in a togalike night-dress, his hand raised in a gesture recalling Christ the Sovereign; and holding the boy, George's wife, the actress Berta Drews-George. The family dog, a Great Dane called Fellow II, and the crossed spears, part of the weapons collection in George's residence on Kleiner Wannsee, emphasize the belligerent character of the actor, who, half butcher, half wrestler, seems on the verge of bursting out of the constricted, cluttered space. AS

Max Beckmann (1884–1950)

78 *Birth* 1937
Oil on canvas, 121 x 176.5 cm

Birth and *Death* were painted during Beckmann's period of exile in Amsterdam, in 1937–38, and were probably conceived as an ensemble. In both compositions the mysterious scene centers around the figure of a reclining woman. The birth is apparently taking place in a circus wagon. The main protagonists, whose figures form a cross, are the mother lying in a bed that seems much too small for her, and a midwife holding the new-born infant in her arms. Life is still an open book to the child, but a pre-monition of its night side casts itself across the page before it has hardly begun. As a clownlike figure in the foreground beats his drum, the curtain before the dark window billows in the wind, its end metamorphosing into an enigmatic mask. AS

Max Beckmann (1884–1950)

77 *Portrait of the George Family*
1935
Oil on canvas, 215 x 100 cm

Painted in Berlin, Beckmann's portrait of Heinrich George and his family was inspired by a performance of Schiller's *Wallenstein*. The actor's first entrance, in which he stormed from the depths of the stage to the footlights clad in a vermilion red uniform, engraved itself on the artist's mind. George's figure accordingly towers above all others in the narrow, vertical format of the composition. A strong heavyset man bursting with energy, he strides into the center of the room, where, judging by his gesture, he is brought up short by the others present: the actress Charlotte Habecker, holding the script as

Max Beckmann (1884–1950)

79 *Death* 1938
Oil on canvas, 121 x 176.5 cm

Oral tradition has it that Beckmann painted this canvas after hearing of the death of Kirchner, with whom he was not personally acquainted. At

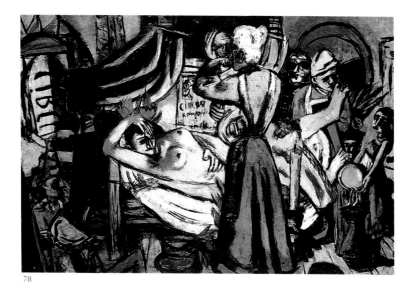

78

the center of the composition lies a dying woman on a bier, her face distorted in terror. In the left foreground a nurse is seated, with an attendant standing behind her; looming before the bier is the figure of an Indian man, with six feet emerging beneath his garment. At the right improbable lovers, a young woman embracing a phallic fish, seem on the verge of floating out of the picture. A tentative explanation of the strange scene, according to the investigations of F.W. Fischer, traces it to Anglo-Indian theosophy and its idea of *kama-loka*, the first stage the soul passes through after death. *Kama-loka* is a phase marked by memories of life and by the sloughing off of unclean and dissolute portions of the soul. The desires and passions that retain their force beyond death, embodied here especially in the woman and fish, lead to a reincarnation. *AS*

79

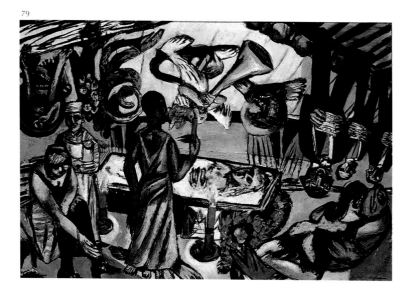

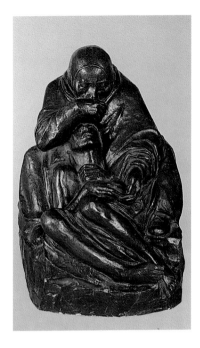

including the death of her youngest son, Peter, in the war in 1914, which she considered her duty as an artist to come to terms with. She took her credo from Goethe: "Seed-corn must not be milled!" In *Pietá* the artist addressed a perennial motif of Christian art, but divorced it from the religious context and transformed it into a universal metaphor for maternal grief. On October 21, 1937, she noted about this group, whose nuanced plasticity recalls Rodin and whose ample folds of drapery recall Barlach: "Now it has become something in the nature of a Pietá. The mother is seated, and has her dead son on her lap, between her knees. It is not pain any more, but meditation." Draped in a heavy cloak, the mother bends protectively over the naked, cold body of her son, preparing to lay him out, and with a last, tender gesture of communion attempts to come to terms with her loss. *FJ*

Käthe Kollwitz (1867–1945)

80 *Pietá (Mother with Dead Son)*
1937–38
Bronze, 38 x 27 x 39 cm

Protest, mourning, and social commitment pervaded Käthe Kollwitz's work from the early cycles of prints to the last, and her sculpture was no exception. She was confronted with human poverty and need in her husband's doctor's office in a northern, working-class area of Berlin. Then came personal strokes of fate,

Werner Heldt (1904–1954)

81 *Berlin Cityscape* 1930
Oil on canvas, 75 x 101 cm

After graduating from art school and traveling to Paris in spring 1930, Werner Heldt began one of the most productive years of his career. In what Lucius Grisebach calls "the most perfect of all his works," the artist renders the facades and walls of the Berlin buildings visible outside his window as a series of interlocking, almost abstract planes in subdued colors. This canvas marked the beginning of Heldt's intensive fascination with views through a window, a motif he would later metaphorically combine with that of the sea to produce a visual formula that reflected his personal philosophy. *FW*

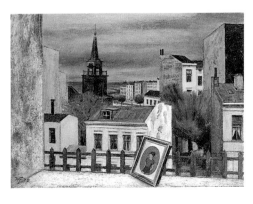

Karl Hofer (1878–1955)

82 *The Black Rooms II*
1943
Oil on canvas, 149 x 110 cm

The traumatic experience of compulsory internment during the First World War triggered the appearance of ominous and admonitory motifs in Hofer's painting after 1919. A convinced democrat and pugnacious by nature, he responded to the growing Fascist threat by lending his depictions of masqueraders, messengers of ill tidings, and demons a truly prophetic aspect. Hofer's style, Expressionism modified by realism, encompassed two, seemingly contrary worlds: a nostalgically classical one of human figures and landscapes on the one hand, and, on the other, a nightmarish vision of the destruction of all traditional values.

The first version of the present painting, executed in 1928 in Berlin, was among the 150 canvases and 1,000 drawings that were destroyed during an air raid on the city in March 1943. The summer of that year found Hofer, temporarily accommodated in a private mental clinic, attempting to reconstruct his life's work. In *The Black Rooms* he employs sharply contoured, schematic figures and a dramatic play of light and dark to evoke a ghostly labyrinth in which pursuers and pursued seem equally lost — a dark room with gaping doors, in the center a nude drummer, flanked by two nude visitors from no-man's-land. Silhouetted against the blind window in the background stands an ominous, dark figure, as another clad in a hangman's cape leaves the room for some unknown destination. Matte hues of blackish brown, flesh color, dirty violet, and blue set against the garish illumination from the barred windows, evoke an atmosphere of inextricable confinement and guilt.

FW

Wilhelm Lachnit (1899–1962)

83 *Articulated Dummy (Lay Figure)*
1948
Mixed media on panel, 75 x 110 cm

In his still life with a lay figure, Lachnit metaphorically addressed the relationship between art and politics obtaining in East Germany, which culminated between 1948 and 1953 in the so-called Formalism Debate and which continued to preoccupy artists in what soon became the German Democratic Republic. The figure used for anatomical studies offered the teacher at the Dresden School of Art a perfect model in two senses. First, it allowed him to demonstrate the aesthetic principles he advocated, regarding the equal weight of objects arranged within a shallow space. Second, the ghostly vitality and automatism of the lay

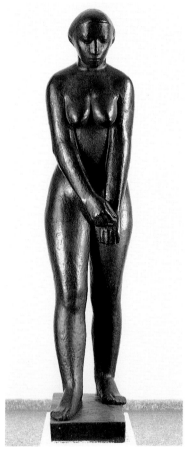

figure inspired Lachnit to make a metaphorical statement of a kind that went back to Mannerism, and later informed the work of de Chirico, Grosz, and Dix. After making numerous preparatory studies in charcoal, Lachnit focused the composition on two creatures involved in a silent, gesticulating debate, the mechanical man disguised in a head mask and gloves attacking his eerie, disembodied opponent on the table before him. Cool greens against a violet ground underscore the ominousness of an automaton designed to serve man and now, absurdly, become his master. FW

Gustav Seitz (1906–1969)

84 *Woman in Fetters* 1947–49
Bronze, 155 x 38 x 54 cm

"I attempt, for all the translation involved in the creative process and the fitting use of materials, to give my sculptures a look of the self-evident and, as it were, the natural, and not to do artificial violence to the model provided by nature," wrote Gustav Seitz in 1955. His credo manifests itself in rigorous yet sensitively handled figures whose sensuous, swelling

volumes were influenced primarily by Maillol. In the female nude of *Woman in Fetters*, content also comes into play, for the statuesque, self-contained, archaically simplified figure is subjected to a stricture that signifies an acceptance of, and submission to, adversity. "The profound experience of our age was the source of the work," explained Seitz, who evidently intended the sculpture to embody both the Germans' sense of guilt and their renewed faith in life after the war. *FJ*

Horst Strempel (1901–1975)

85 *Night over Germany* 1945–46
Triptych; oil on canvas,
center panel 150 x 168 cm,
side panels 150 x 78 cm,
predella 79 x 166 cm

Strempel's *Night over Germany*, purposely given the form of an altar painting, represents one of the many immediate reactions on the part of German artists to the Third Reich and, above all, to the existence of the death camps in which human beings of faiths, nationalities, and political creeds unacceptable to the Nazis were incarcerated, tortured, and murdered. This painting is a monument to the victims, an homage to their sufferings in unspeakably horrifying circumstances. Depicted on the left-hand panel is a premonition of the evil to come, and on the right, the fate of the European Jews. The predella, below, depicts the clandestine activities of prisoners' committees in the concentration camps. In the central panel, the survivors rise up as if from the abyss, some broken and still unbelieving, others extending their arms with the branded inmate numbers, all gradually gathering courage to go on.

This starkly expressive image is a compelling reminder of the darkest chapter in German history, and it partakes of the Berlin artist's own, first-hand experience of imprisonment. After studying in Breslau with Oskar Moll and Otto Mueller, and in Berlin with Karl Hofer, Strempel had emigrated to France in 1933, where in 1939 he was arrested and interned in a labor camp. *FJ*

became the point of departure for composition: "Painting — that means forming the image out of color." In the 1950s Nay began to employ pure hues set in rhythmic configurations that drew sustenance from the inherent "Formative Value of Color" ("Gestaltwert der Farbe," the title of a theoretical essay Nay published in 1955). Continuing to develop and ramify this approach, he soon became one of the foremost colorists in the German abstract art of the period. The present painting, begun in late 1967, is a late work in which the repertoire of the preceding decades is recapitulated and transformed. The full chorus of color seen in earlier compositions is reduced to a narrow range of light-dark contrasts. Bright, hard-edged floral shapes recalling the late Matisse cut-outs flow across the canvas and virtually continue beyond its edge, lucid, almost harsh juxtapositions of hue and form representing a summing-up of a life's work. *MT*

Ernst Wilhelm Nay (1902–1968)

86 *Ocher, Yellow, and Dark Blue*
1968
Oil on canvas, 162 x 150 cm

The Nationalgalerie collection contains twelve paintings by Nay, which vividly illustrate his development. After beginnings in German Expressionism, the 1930s already found him working in a dynamic, abstract style in which color increasingly

Hans Uhlmann
(1900–1975)

87 *Little Carousel*
1958
Steel, 160 x 140 x 140 cm

Hans Uhlmann, who made his living as an engineer until 1945, began in 1925 with his first sculptural experiments, which led in the 1930s to cagelike configurations in wire and sheet metal. His inspiration came from artists such as Rudolf Belling, Alexander Calder, and Naum Gabo, whose credo — formulat-

ed in collaboration with Antoine Pevsner in their "Realistic Manifesto" of 1920 — came to determine Uhlmann's aesthetic: "We dispense with volume as an expression of space — We reject solid mass as a design element.... We declare that these elements of art have their basis in a dynamic rhythm." After 1945 the Berlin sculptor developed a constructivist, abstract approach whose radical logic was unique in postwar Germany, and paved the way for the technology-oriented, abstract style that became one of the main trends there.

Little Carousel combines a stringent structure with a rhythmic play of linear elements extending into space, which, emerging from a hub, create an impression of virtual rotation. The slight incline of the supporting rods lends additional tension to the piece, suggesting a continual interplay between mechanical function and the energies underlying the processes of growth. The artist, also known to have produced an outstanding graphic oeuvre, wrote in 1968: "I love the multifariousness of drawing and the possibilities it offers in terms of greater spontaneity, while in sculpture I attempt to achieve a greater degree of reduction and concision." *FJ*

Willi Baumeister (1889–1955)

88 *Aru 5* 1955
Oil on canvas, 185 x 130 cm

Like Nay, Baumeister laid the foundations of his art as early as the 1920s and remained in Germany despite Nazi harassment for being a "degenerate artist," and thus emerged in 1945 as an uncorrupted exponent of the modern tradition. What he had begun in the early "Wall Paintings" (see no. 52: *Figure with Stripes*, 1920) was continually ramified and enriched, even in his isolated situation of the 1930s, and was given theoretical underpinning in writings such as *Das Unbekannte in der Kunst* (On the Unknown in Art), written in 1943 and first published in 1947, after which several subsequent editions were published. The extraordinary echo Baumeister's art received during the final decade of his career, his influential teaching activities, and his fruitful contributions to the public discussion on modern art were signs, as Dieter Honisch has said, of "the central and crucial role he doubtlessly played in Germany and in the art of the postwar period."

In the last major cycles of "Montaru" (53 variants; 1953–55) and "Aru" (24 canvases; most from 1955), the pictorial plane is dominated by great black "continents," along the edges of which play smaller forms and flickering lights which lend the dark, central form a certain ambivalence. One's initial impression that it is spreading to engulf its surroundings gives way to the sense that it is actually being encroached upon from the void outside. An oscillation between being and nothingness, in which expanding darkness and tentatively advancing light are held in a precarious equilibrium. *MT*

Karel Appel (b. 1921)

89 *Woman and Dog on the Street* 1953
Oil on burlap, 143.5 x 110.2 cm

"Canvases like clenched fists, paint masses like lava flows, a coloration that devastates and incinerates the eye," said Lucebert of the art of his comrade-in-arms from the days of the Cobra group. In Appel's own view: "Sometimes my work seems very childish or naive, schizophrenic or imbecilic. But this was important for me. Because for me, the material is the paint itself. Paint expresses itself." The Dutch artist, who now lives in Paris and Monaco, was a founder of the only group of experimental artists that reacted aesthetically and politically to the new situation in postwar Europe. Inspired by the Belgian poet Christian Dotremont, young Belgian, Dutch, Danish, and French artists met in 1948 at the Hotel Nôtre Dame in Paris to establish an international association, giving it a programmatic name formed of the first letters of the capitals Copenhagen, Brussels, and Amster-dam. Its members were Pierre Alechinsky, Corneille, Appel, Constant, Lucebert, Anton Rooskens, Ejler Bille, Asger Jorn, Egill Jacobson, Carl-Henning Pedersen, Jean-Michel Atlan, and Jacques Doucet. With a figuratively oriented, spontaneously expressive, and consciously primitive style, which took up the tradition of German Expressionism and anticipated American Action Painting of the 1950s, Cobra set out to attack the bourgeois restoration and a modern art bogged down in convention. In their journal of the same name the group, which existed until 1951, discussed a socialist model for society and issues of experimental aesthetics. For all the diversity of their work, the members shared a common belief that art could be used as an "intellectual weapon ... to change the world," as Constant wrote in the first issue of *Cobra* in early 1949. The young painters found their ideals in any type of art that was non-academic, above all children's drawings and the pictures of the mentally ill, in folk art and graffiti, though they also derived inspiration from Miró, Dubuffet, Lam, and Giacometti. An attempt to plunge to the deepest wellsprings of life was also reflected in their motifs — animals, mother and child, eyes, sun and moon. Cobra's aim, said Appel in 1972, was to start over from the beginning, "like a child — fresh and new." Appel found the unison of thought and action advocated by the group solely in the world of children and animals. This is reflected in the child-like figure, cat, house, and tree in the present painting, which was part of the Otto van de Loo bequest to the museum. *FW*

Karel Appel (b. 1921)

90 *Confrontation of the Worlds*
1958
Oil on canvas, 420 x 250 cm

As prodigious as its theme is the format of this work, which permits Appel to unleash his vision in floods of paint transmuted into a universal flux. The palette knife is the preferred extension of this artist's hand and its furious gestures. The paint mass twists and turns, bucks and fights as if in revolt against all constriction of form in this *Art informel* canvas of Appel's Paris years. "My paint tube is like a missile that describes its own space," he said in 1962. "I try to make the impossible possible. What will happen I cannot predict.... Painting, like passion, is a feeling full of truth." Spontaneity and exploitation of chance had been basic tenets of the Cobra philosophy from the start.
FW

Constant (b. 1920)

91 *War* 1950
Oil on canvas, 99.5 x 60 cm

Constant was the only painter in the Cobra group to address current events directly and to express his experience of them. A 1949 journey from Copenhagen through war-devastated Germany triggered a series of war paintings, which drew further sustenance from the Korean War, which was then at its height. In the present canvas Constant depicts, with eruptive force, a burning house spewing a black cloud of smoke and an escaping figure, screaming and shaking its fist as if to curse fate. *FW*

Pierre Alechinsky (b. 1927)

92 *The Theater and its Double*
1970
Oil, acrylic, and tempera on paper,
mounted on canvas, 175 x 220 cm

After studies in Brussels, the Belgian
painter Pierre Alechinsky became the
youngest member of the Cobra group
in 1949. In 1951 he organized the
group's second exhibition in Liege,
and after it had disbanded, he moved
to Paris. A crucial influence on his
development was his contact with
Japanese graphic artists in Kyoto,
whom he visited in 1955. A film,
Calligraphie japonaise, ensued from
this encounter.

Alechinsky depicts figurations
derived from myth in a vehemently
gestural style, producing idiosyn-
cratic and subtly demonic scenes.
The elemental flux of the pictorial
space is suffused with metaphoric
references which distantly recall
Ensor and Nolde. In the mid-1950s
the puissance of Chinese and Jap-
anese ideographs began to have an
increasing influence on Alechinsky's
work. *The Theater and its Double*,
whose title alludes to a 1938 antho-
logy of the same name by Surrealist
author Antonin Artaud, illustrates
the way in which these Asiatic ara-
besques furthered Alechinsky's ten-
dency to ornamental, serial arrange-
ments of magically evocative form.

FJ

Asger Jorn (1914–1973)

93 *Immobile Ballet* 1957
Oil on canvas, 162 x 130 cm

In 1948 Danish artist Asger Jorn was
among the founding members of the
Cobra group, which came into being
largely as a result of his initiative.
Jorn established contacts with others
in the Danish art scene, who were
pursuing the same aims as the Cobra
artists, as graphically expressed by
the Dutchman, Constant, in 1948:
"A painting is not a structure made of
colors and lines, but a beast, a night,
a scream, a human being, or all these
at once."

This absoluteness and attempt
to return to the roots of painting,
which are evident in Jorn's work, are

tempered by an exquisite balance between abstraction and figurative meaning. *Immobile Ballet* is a case in point, with its hovering, tentative forms that at one moment congeal into evanescent fabulous beasts, and at the next dissolve into an interplay of pure form and color.

FJ

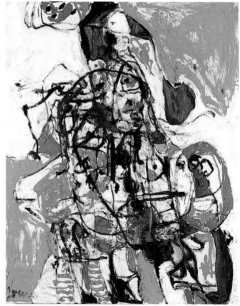

Asger Jorn (1914–1973)

94 *The Witches of Pozzo Garitta* 1954–56
Oil on canvas,
145 x 109 cm

Jorn's imagery oscillates between light-heartedness and melancholy. An instance of the latter is *The Witches of Pozzo Garitta*, with its dark tonalities punctuated by flecks of bright color. The canvas was based on memories of a carnival parade Jorn saw in 1954 on the Piazzetta Pozzo Garitta in Albisola. But he has transformed the carefree masquerade into an ominous scene, in which innocent fun takes on chilling undertones. As Jorn's friend and fellow-artist Egill Jacobson once said of him: "He takes us away from Klee to bring us closer to Edgar Allen Poe. We must go out into the great, cosmic night ... in order to experience the instincts ... which are to be found in the transition between dream and reality."

FJ

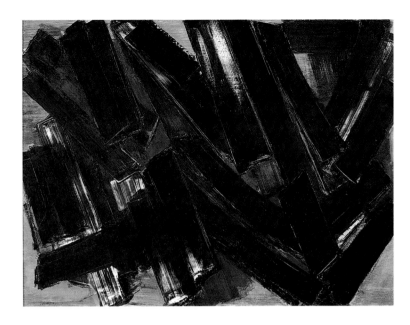

Pierre Soulages (b. 1919)

95 *Black, Brown, and Gray* 1957
Oil on canvas, 96.5 x 130 cm

In their programmatic rejection of
description ("refus de la déscrip-
tion"), Soulages's paintings of the late
1940s onwards provided an import-
ant stimulus for the fledgling Ecole
de Paris. Combining spontaneous
gesture with a fine sense of composi-
tion, they established a counter-
weight both to Action Painting and
to the geometrical abstraction of the
period. Soulages's color range is
often reduced to the point of mono-
chromy, and the paint is applied with
broad strokes of the palette knife,
which for all their energy still main-
tain compositional balance. "I have
always been of the opinion that the
more limited the means were, the
stronger the expression would be,"
explains Soulages. He is considered
to be one of the most outstanding
representatives of lyrical abstraction
in France. *MT*

Hans Hartung (1904–1989)

96 *Black on Rust Brown* 1957
Oil on canvas, 148 x 116 cm

An émigré from Germany in 1935
and French citizen since 1945, Hans
Hartung, with Wols and Soulages,
was one of the founders of a Euro-
pean variant of Action Painting that
set a classical pictorial structure
against the all-over compositions of
the Americans. For the Europeans the
spontaneous act of painting was
related to a delimited pictorial space,
and took place in a dialogue with
the predetermined plane. Hartung
discovered the autonomous value
of trace and gesture as early as the
1920s, though only after his first one-
man show in Paris in 1947 did his
work become widely known. With
Wols he was one of the major pro-
tagonists of *L'Art informel* and
Tachism. Yet passive automatism was
not his way. His working process
combined spontaneous action with
reflective judgment, an "empathy
with the laws of the universe, with
the order that underlies everything,"
as he said in 1974. In his paintings of
the 1950s rapidly executed linea-

tures and sweeping strokes form skeins or fan-like shapes on vibrant, monochrome grounds, energy-charged "gestures of pathos"(Werner Haftmann), whose dynamic force and motoric immediacy are only heightened by the sophistication of the compositional context. This approach has little to do with symbolism or the recording of psychological states, yet it takes its point of reference in reality, and as Hartung said in 1976, "is shaped by it and reacts to vibrations that come from outside and from within."

MT

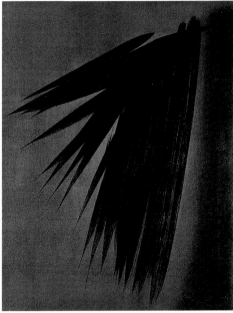

96

Serge Poliakoff (1900–1969)

97 *Composition with Red and Yellow Shapes* 1963
Oil on canvas, 162 x 130 cm

Born in Moscow, Poliakoff went to Paris in 1923, where he initially made a living as a guitar player. His compositions are suffused with a quiet harmony, and lack all reference to things in the outside world. They are composed of chromatically modeled planes and areas of color in which the canon of icon painting reverberates. The shapes grow inwards from the edge of the canvas, freely intermingling and mutually heightening one another to produce a sonorous chord of color. Not dynamics but equilibrium is the keynote of Poliakoff's painting. "Abstract art comes more from inside, and goes more inside," he said in 1954. And in 1962,

"When a picture is silent, that means an artistic success to me. Some of my paintings begin with an enormous tumult, they're explosive, but I'm not satisfied until I have brought stillness into the picture." *MT*

97

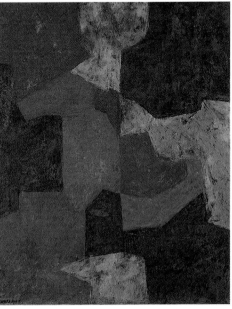

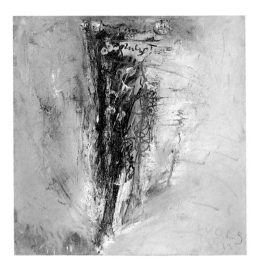

Wols (Alfred Otto Wolfgang
Schulze; 1913–1951)

98 *Painting* 1946–47
Oil on canvas, 80 x 80 cm

99 *Yellow Composition* 1947
Oil on canvas, 73 x 92 cm

Wols's oeuvre comprises roughly
2,000 watercolors and drawings, and
80 paintings in oil. The
latter were done in Paris,
in the winter of 1946–47,
and in the years 1949
to 1951. *Painting* and
Yellow Composition are
among the major works
of that productive winter,
in which Wols summed
up his previous develop-
ment as a painter and, as
an offshoot, became one
of the first protagonists of
the strain of abstract art
known as Tachism. *Paint-
ing*, though the title of
this work is likely not
Wols's own, nevertheless
amounts to an artistic
program. This may be inferred from
the signature, which, apart from the
artist's name, includes the date of his
birth, May 27, 1913.

Wols's painting career began in
the late 1930s with relatively small
watercolors inspired by his encoun-
ter with Surrealism, both visual and
literary. The dreamlike yet ultimately
descriptive character of these works

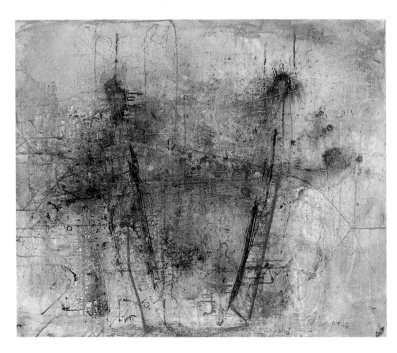

on paper gradually changed, after the artist's release from a detention camp, into a recording of structures vaguely reminiscent of organic configurations and growth. Both *Painting* and *Yellow Composition* elude a clear interpretation in terms of content, allowing for associations and fantasies on the part of the viewer. The real drama of such imagery — especially in the case of *Painting* — derives from the violence of the act of painting itself, which concentrates on the center of the image. Attacked again and again, the area becomes a seething volcano of intertwining, slashing strokes. The pictorial event in *Yellow Composition*, though also related to the center, runs a different course. Grids and flecks of paint emerge from the yellowish-green ground and transform the picture plane into a nervously vibrating membrane which seems stretched by the diverging red lines. *AS*

artist's work. He became obsessed with the idea of capturing the look of a figure as it receded from him, including the increasing physical distance and its effects on his own act of perception. In the course of work the figures grew smaller and smaller until finally they disintegrated beneath his hands. It was only after the war that Giacometti became capable of retaining a certain mass, and his figures became taller and more solidly planted. Their strict frontality seems to compel the observer to maintain a certain distance to them. And it is only when we scrutinize them from a distance that the figures emerge from the amorphous mass which, seen close up, dissolves into the countless hollows and projections of a surface tormented by the artist's hand.

AS

Alberto Giacometti (1901–1966)

100 *Slender Woman without Arms*
1958–60
Bronze, 68 x 27 x 13 cm

In Paris during the 1930s Giacometti produced a rich and fascinating Surrealist oeuvre before, in 1935, he "stepped out of modern art history and, after ten years of loneliness, stepped into general art history bringing fundamental innovations" (Reinhold Hohl). The figure that now served him as a prototype, derived in part from the tradition of early Mediterranean idols, was the extremely slender, elongated, hieratic figure that appeared to grow into the sky from a heavy base. Giacometti's female figures, at least, were always designed to be seen *en face*, representing his visual memory of a whole person. With just such a memory of his girlfriend, Isabel, seen on the boulevard Saint-Germain in Paris, began the great transition in the

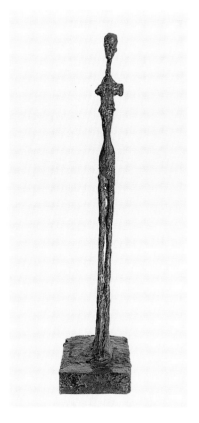

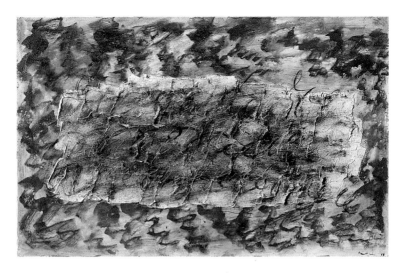

Jean Fautrier (1898–1964)

101 *Swirls* 1958
Oil on cardboard and canvas,
81 x 130.5 cm

It was not until the 1940s, after his exhibition entitled "Les Otages," that the significance of Fautrier's work was recognized and honored. A term coined by Michel Tapié, "l'art autre" — an art outside the previous traditions of French painting — characterizes this French artist's contribution to postwar abstraction, which despite all its similarities to the approach of American artists, such as Jackson Pollock, had a quite different visual thrust. Although Fautrier's work has certain compositional affinities with that of Wols or Henri Michaux, the artist tended to avoid gestural and symbolic effects. He concentrated on the physical nature of color, spreading warmed impasto paint across the canvas with a palette knife, then sprinkling powdered pastel chalk over the wet surface. "The signs created in this way," said Tapié in 1973, "did not necessarily coincide with those incised in the impasto; rather, they brought strong counterforces into play, which bear more comparison to building methods than to the contrapuntal relationships of a classical norm that has

gone rather astray." In Fautrier's work the paint no longer serves to evoke an illusionistic or referential image but takes on intrinsic value in itself. Although the sinuous movement of the paint in a canvas like *Swirls* may inadvertently remind us of natural phenomena, such as waves on water, the pictorial space was intended to be self-referential, autonomous. "In art," said Fautrier in 1959, "all that counts is the sensibility of the artist: art is only a means to express this sensibility, though a crazy means, without rules or reason." *EB*

Jean Dubuffet (1901–1985)

102 *The She-Bear* 1950
Oil on canvas, 116 x 89 cm

This painting belongs to a series of "Corps des dames" (Women's Bodies), which Dubuffet executed in 1950–51 and about which he wrote in the latter year: "My intention was that the drawing should not lend the body any final form, just the opposite: it was supposed to prevent its taking on any precisely defined form."

After his early essays Dubuffet worked as a wine dealer for many years, and did not begin to devote himself entirely to painting again until 1942. His approach was largely determined by the ideas and aims of the Surrealists. An intensive study of the art of children, the mentally ill, and "primitive" cultures — an art he collectively termed *L'Art brut*, or raw art — encouraged Dubuffet to concentrate on the unconventional, seemingly amorphous imagery that could be coaxed from the subconscious mind. The female figure in *She-Bear*, bloated and as if flattened onto the canvas, appears to represent a symbiosis between animal and human, and seems to have been conceived by an imagination in the primal stages of its evolutionary development. With this shocking, ungainly creature Dubuffet projects a symbol, freed of every influence of civilization, of the ultimate inexplicability of the life force.

FJ

Jean Dubuffet (1901–1985)

103 *The Hunter* 1949
Oil on canvas, 88.8 x 116.4 cm

Dubuffet was intrigued by unaesthetic, supposedly ugly things like random marks and patches on walls, as well as by stark and monotonous regions of the earth such as oceans, deserts, and snowbound wastelands. *The Hunter*, part of the series of "Paysages grotesques" (Grotesque Landscapes) done between 1947 and 1949 after three trips to the Sahara, accordingly has the appearance of random scribblings that have accumulated into a labyrinthine network. Dubuffet weaves mystery into simplicity, reveals organic growth to be an all-pervading flux. The rough textures and lineatures sharply incised into the thick impasto anticipate the graffiti art of recent years. "I wanted to show," said Dubuffet, "that what many consider ugly and what they no longer see also possesses its wonder."

FJ

Antoni Tàpies (b. 1923)

104 *Painting with Bedsteads*
1967
Sand, plaster, powdered marble, and oil on wood, 275 x 330 cm

Tàpies is one of the painters who significantly contributed to the revitalization of European art after the war. Following Surrealist beginnings in the 1950s, he soon developed an innovative style based on the sheer presence of materials, producing meditative imagery whose buckled, cracked, incised surface might recall the Catalan landscape or some humble interior. Yet in Tapiès's hands, such subjects become metaphors capable of evoking fundamental themes such as human frailty and mortality. *DH*

Arman (Armand Fernandez; b. 1928)

105 *A Spoon for Daddy, a Spoon for Mommy* 1962
Metal spoons and synthetic resin on wood, 156 x 93.5 x 9.5 cm

In Arman's work, apparently random accumulations of commonplace objects are brought into a coherent visual context, which raises them to a new level of interpretation.

Arman, with Yves Klein, Jean Tinguely, and the critic Pierre Restany, was one of the founders of the *Nouveaux Réalistes* group in 1960. Their aim was to cut loose from what they felt was the arbitrariness of painterly abstraction, as well as to reject all figuration of *L'Art brut* variety. The positive focus of their work was a new conception of reality, influenced by existentialist philosophy. The *Nouveaux Réalistes* placed greater trust in the material presence of the painting than in the belief that a painting must contain some meaning imposed on it by its illusionistic nature. *DH*

Yves Klein (1928–1962)

106 *IKB 49* 1960
Pigment on canvas on plywood,
195 x 140 cm

Yves Klein was the artist who Pierre Restany never tired of declaring the leader of the *Nouveaux Réalistes* movement in Paris. The group mounted a radical attack on the traditional aesthetic values of *peinture*, or fine painting, which had actually started with the Cubists decades before.

Born into a family of artists in 1928, the young Klein was lying stretched out on a beach in Nice one day when "the deep void, the blue depths" of the sky struck him with the force of a vision. This experience played an important role in his art. Klein dreamed of a "Blue Revolution," an art based on a single color which would liberate painting from outmoded meanings and substitute for them the concept of "le vide," the void. His ideas spread like wildfire across a postwar Europe to which art that conveyed messages of any kind had become suspect. Fire, water, air, color, and, in his "Anthropométries," the physical energies of the human body set free, became the weapons with which Klein set out to vanquish academic painting. His quest was

destined to be cut short by his premature death, at the age of only thirty-four, in Paris. *DH*

Lucio Fontana (1899–1968)

107 *Spatial Concept: Expectation*
1965
Oil on canvas, slit, 133 x 100 cm

Along with Yves Klein, who by his mid-thirties collapsed under the strain of living so intensely, the much

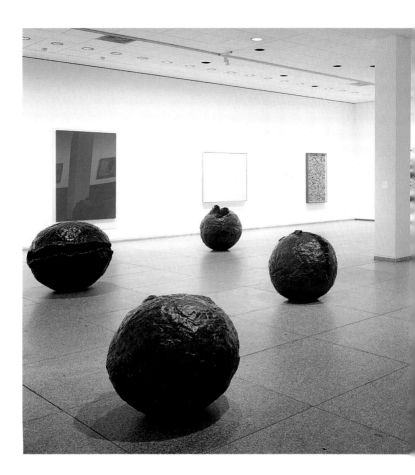

older Lucio Fontana — born in 1899 in Argentina — was a leading figure in the reintroduction of avant-garde art in postwar Europe. Very much on his own, and drawing inspiration only from the Constructivist and Concrete artists of the 1930s, Fontana developed the conception of an art open to the surrounding space, which he formulated in 1948 in his manifesto "Spazialismo." Between 1958 and the middle of the 1960s he produced a series entitled "Spatial Concepts," canvases in which space was engendered within the painting, and thus within the plane surface, by means of razor-sharp incisions. The issue of the flat painting surface containing actual space rather than conveying a mere illusion of it had never before been so radically addressed.

This uncompromising and implacable handling of the image, never dared by a European artist before, amounted to a challenging hypothesis formulated with minimalistic means. *DH*

Lucio Fontana (1899–1968)

108 *Spatial Concept: Nature*
1959–60
Five plaster sculptures, tinted,
44 x 90 cm; 86 x 88 cm; 76 x 84 cm;
93 x 105 cm; 87 x 107 cm

The new definition of plane and space in Fontana's painting led logically to a new definition of solid bodies in space. This is illustrated by his sculptural environment, *Nature*, which consists of five spheroidal ele-

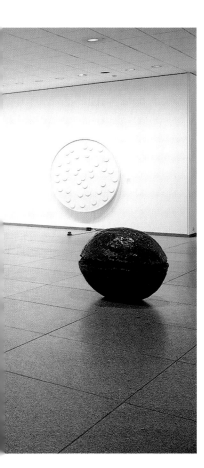

In 1946 Fontana wrote in his "Manifesto Blanco": "The new art derives its elements from nature. Existence, nature, and matter form a complete unity. They unfold themselves in time and space. Change is the fundamental condition of existence. Movement, the ability to develop and evolve, is the fundamental condition of matter — because it consists of motion and of nothing else. It develops perpetually; color and sound in nature are bound up with matter. Matter, color, and sound, in their motions, are the phenomena whose simultaneous development is the task of the new art. The color applied to a plastic volume assumes spatial meaning and takes on ever new forms consecutively over time. The sound is generated by instruments hitherto unknown. Previous instruments do not have the requisite resonance and do not elicit the necessary variety of sensations.

"By means of a plastic and malleable substance, corporeal, continually changing forms must be created which, after their installation in space, engender dynamic images by means of simultaneous effects. This is how we praise nature in its complete being. Matter in motion manifests itself in its all-encompassing and everlasting existence by developing in time and space and taking on different existential states in the course of continual change. In our view, if human beings are to find their way back to their original capabilities, they will have to establish a bond with nature by confronting it in a new way." *DH*

ments. Just as a monochrome white, empty painting is given an evocative meaning by a single incision (see no. 107), here three-dimensional forms are divested of traditional associations with figures or symbols. Due to their undefined, raw, almost primordial shapes, they annex the space and seemingly draw the walls of the room towards them. This environment comprises the original plaster sculptures, of which smaller bronze versions are now in the Kröller-Müller Museum, Otterlo, and the Hirshhorn Museum, Washington, D.C. Further individual pieces are known to exist, in terracotta as well as bronze. Yet the present environment, being the original version, reflects the artist's vision more faithfully than any other.

Günther Uecker (b. 1930)

109 *Informal Structure* 1957
Nails, plaster, and white paint on canvas
on wood, 100 x 70 cm

A native of Mecklenburg, Günther
Uecker drew attention to himself
with a series of idiosyncratic objects
featuring nails. After first experiments
driving nails through his own mono-
chrome paintings, the nail gradually
became a signature element with the
aid of which Uecker reworked not
only paintings but various consumer

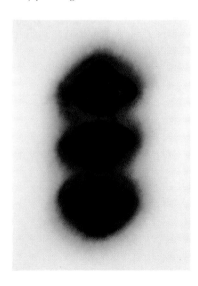

products, both destroying their fetish
character and transforming them into
new, autonomous, light-modulated
objects in space. *Informal Structure*
of 1957, one of the artist's very first
nail works, impressively demon-
strates the radical simplicity of his
method of extending the picture
plane into the surrounding space.
Textures and grids, in manufactured
or manually produced objects, were
the stylistic means with which
Uecker and the Zero artists banished
gesture and composition from the
painted image. *DH*

Otto Piene (b. 1928)

110 *Untitled (Smoke Painting)*
1962
Soot on canvas, 170 x 120 cm

After a series of paintings based on
regular grids, Otto Piene, initiator
and spokesman of the Zero group,
developed a unique method of
"painting with smoke." A canvas
held over a candle absorbed its heat
energy, began to buckle and swell,
producing shapes with a raised,
encrusted center and margins that
gradually and delicately merged with
the surrounding canvas. A natural
process taking place outside the pic-
ture was used to engender visual
phenomena within it. As in Uecker's
work, the conditions of creating
become the true subject of Piene's
paintings. *DH*

Piero Manzoni (1933–1963)

111 *White Squares* 1959
Oil on canvas, 130 x 150 cm

Few artists have mounted a more
radical attack on the aura of art than
Piero Manzoni before his premature
death in 1963. He filled paintings
from edge to edge with insignificant,
unprepossessing materials, enclosed
endless lines in tin cans, and assem-
bled pictures from small, square
pieces of canvas. In his work, the

sublime whole of a painting is reduced to a patchwork, but one in whose regular order traces of the old, rejected aura may still be detected.

The artists of the Zero group were determined to break out of Germany's post-war intellectual isolation. They cut themselves loose from every tradition, including that of Expressionism, which continued to inform the abstract painting of the day. By beginning with a tabula rasa, they hoped to be able to visually manifest dynamics, light and motion, time and space with unprecedented intensity. Zero took its cues from Fontana, Manzoni, and Yves Klein, who had divested the painted image of every emotional and substantial reference, but also from Jean Tinguely, who responded to the re-emergent postwar belief in technological progress with ironic machines designed to produce nothing but art.

DH

Jean Tinguely (1925–1991)

112 *Red Relief* 1978
Welded metal and wood, partially painted in red, mounted on a steel framework, with electric motors,
178 x 288 x 112 cm

Tinguely conveyed irony and wit to an art scene that was struggling to retain concepts such as sublimity and profound meaning in art. Tinguely confronted both these, and the proliferating materialism of a growth-

oriented society, by setting art in motion, lending it the character of an event which was not without entertainment value. But rather than leaving motion up to chance, he produced it by means of small electric motors, which lent motion the form of a controlled process. The surprising and often provocative movements of Tinguely's objects were supplemented by acoustic effects —noises that introduced a previously alien factor into the art of sculpture. *DH*

Heinz Mack (b. 1931)

113 *Untitled* 1960
Synthetic resin on canvas, 160 x 120 cm

Heinz Mack lent the "art of light" envisioned by the Zero group perhaps its most compelling form. With his steles, motorized pieces, and activities in uninhabited regions like the Sahara, he sought out spaces in which his art could freely unfold, independent of the art market and the museum. Perhaps it is not an exaggeration to say that with Mack, as with Zero as a whole, a new environmental consciousness arose that, going beyond traditional artistic intentions, not only revealed certain working methods and creative processes, but set luminous signals in a previously uncharted and unappreciated no-man's-land.

An example is the present painting, executed with a rubber scraper or windshield wiper, which exudes a feeling of light and space at odds with the banal method used to produce it. The image is also pervaded by the factor of time, which lends it the character of a space-time event.

If today we have become used to considering a painting not merely as a medium for messages, but as an object in and of itself, this is certainly largely due to the efforts of *Nouveaux Réalisme* and Zero. Artists in Germany after the war found it impossible to return to painting until the medium had been liberated from every taint of ideology. Yet Zero was not a typical artists' group with a clearly defined program. It was more a community of interest, consisting of highly dissimilar artists with diverse aims, who came together at large exhibitions in Amsterdam and elsewhere. The activities of Mack, Piene, Uecker, and the other members of Zero, who had since established contacts with artists in France, Belgium, and Holland, culminated in a collaborative installation on the top floor of the Fridericianum in Kassel for "documenta III" in 1964. This was followed by an extremely successful exhibition at the Howard Wise Gallery in New York.

After their collaboration had led to a breakthrough, the Zero artists each went their own way. Their final exhibition as a group took place in Bonn in 1966. But what made Zero into a legend was not limited to the group alone, nor to its eight years of existence. Its spirituality and openness derived from Yves Klein, its conceptual approach from Piero Manzoni, its concrete rendering of space from Lucio Fontana, and the dynamic movement evoked by the continually changing appearance of their works with changing illumination, finally, was inspired by the brilliant Swiss artist, Jean Tinguely. *DH*

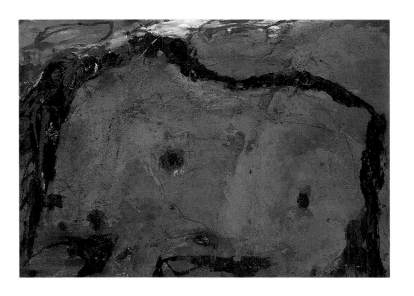

Emil Schumacher (b. 1912)

114 *Palau* 1984
Oil on panel, 170 x 250 cm

Influenced by Wols and one of the major representatives of German *Art informel*, Schumacher considers the act of painting itself to be the true subject of the work. In reaction to what spontaneously emerges beneath his hand on the surface, each subsequent stroke contributes to creating an agitated, earthy texture in fine gradations of intense color. In these islands and sweeping swaths of paint one senses elemental, formative powers being made manifest. *FJ*

Gotthard Graubner (b. 1930)

115 *Toyama II Color-Space Body* 1984
Mixed media, 200 x 200 cm

Graubner's specific theme is color. After beginning with flat surfaces, he developed his paintings into three-dimensional objects ("Cushion Paintings"), and finally, in the 1970s, achieved a synthesis of colored plane and colored object in his *Color-Space Bodies.* Since his travels of this period to the Buddhist countries, Graubner has given many works Asiatic titles. Toyama, the name of a Japanese city, represents a metaphor for a "color infused with soul," in an image in which translucent veils of paint hoveringly encircle an evocation of the Celestial Empire of China. *FW*

Pablo Picasso (1881–1973)

116 *Bust of a Woman on a Gray Background* 1943
Oil on canvas, 116 x 89 cm
On loan from a private collection

Following a Surrealist phase in the 1930s, which culminated in the "Surrealistic Cubism" of the renowned *Guernica* of 1937, Picasso again returned to the Cubist-related idiom seen in his *Bust of a Woman*. In a sense this was not only an aesthetic decision but a political act, for it represented a radical rejection of the neoclassical and traditionalistic streams that then dominated European art. An entry concerning Picasso's work in Ernst Jünger's Paris diary of 1943 is indicative: "Other paintings, such as a series of asymmetrical heads, struck me as monstrous." Picasso replied to such objections in a 1944 conversation with Daniel-Henry Kahnweiler. Arguing from a Cubist standpoint, he stated: "But I intentionally made this 'crooked nose' the way it is ... so that you are forced to see a nose." Such deformations and extreme simplifications had begun to play a part in Picasso's oeuvre as far back as 1907.

In 1943, when this painting was executed, these factors could not help but have the appearance of a conscious reaction to violence and war. The portrait heads of the 1940s evidently also reflect the real and profound threat of the German occupation in Paris. In a radical reversal of the ideal types of human beauty propagated by a racially determined aesthetic, Picasso professed his allegiance to the modern styles, which the Nazis defamed as "degenerate" and identified himself with the artists they persecuted.

His *Bust of a Woman* is reduced to stark, angular forms while the facial features are highly distorted, as if all female sensuality had fled before the onslaught of terror. By means of this distortion Picasso manages to question ironically the equally distorted human image propagated by a racist ideology, and at the same time to lend visual form to the horror of a cold-blooded, systematic culling out of unwanted lives.

Evidently this is not a portrait of an individual, but a universal symbol of the monstrous public stigmatization Picasso must have witnessed in the streets of Paris at the time the painting was done in 1943. It was, after all, in the same year that the German authorities began to force French Jews to wear the Star of David. *EB*

Pablo Picasso (1881–1973)

117 *Reclining Woman with a Bouquet* 1958
Oil on canvas, 130 x 195 cm

The reclining female nude is a motif that appears in every stylistic phase of Picasso's protean oeuvre. In the 1950s we find him mixing various possibilities of visual design, some paintings of the day even displaying naturalistic, Surrealistic, and Cubist elements side by side. What first strikes the eye in *Reclining Woman with a Bouquet* is a Cubist faceting that is limited to the figure, instead, as in purely Cubist works, of applying the technique to other objects and the surrounding space. Yet not even the figure is entirely determined by this principle, for while the face and lower body are treated in terms of planes, the arms and breasts retain a more organic form. The face is divided down the middle, into a half-moon-shaped profile view on the left and a frontal view at the right. The arm thrown over the head seems to impart a turning motion to it, which extends to the rest of the body. This torsion appears especially extreme in

the hip area, where a reclining figure and a seated figure seen from the back appear simultaneously.

The variations of form and concomitant physical deformation seen here are not essentially a compositional issue; rather, they arise from the vital and erotic view of the painter. To Picasso, revealing the beauty of his model could not be a matter of producing a faithful, realistic image in the traditional sense. He had to show the body from all angles, giving it an extreme torsion, which certainly runs counter to our perceptual habits. Our eye, trained by everyday perception of the world around us, attempts to correct the displacements of the parts of the body, and thanks to this active visual process the static depiction of the figure seems suddenly infused with vital movement. In contrast, the almost monochrome, undifferentiated background and the small table with a tuberous plant, possibly an amaryllis, are purposely kept static in character. The diverse treatments of form within the painting are brought together by means of consistently animated brushwork throughout. *EB*

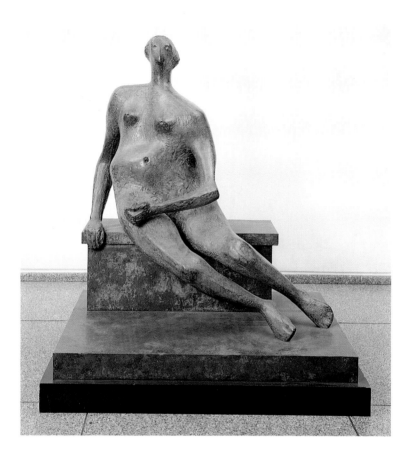

Henry Moore (1898–1986)

118 *Woman on a Bench* 1957
Bronze, 158 x 142 x 105 cm

A miner's son from Yorkshire who studied sculpture in London, Henry Moore was convinced, as he wrote in 1957, that life and art consisted of conflict, and that man must find a synthesis and come to terms with oppositions. The existential tension of which Moore speaks is found in all the works of the English sculptor and draftsman, be they abstract or object-ive in nature. The series of "Seated Figures" — placed on blocky bench-es or before delimiting walls — is no exception in this regard. Executed during the latter half of the 1950s, they all refer in one way or another to the struggle of life. The uncertainty of the seated pose of *Woman on a Bench* reveals intense mental agita-tion, a blend of anxiety and expect-ancy, an indecision whether to act or remain passive in face of what she sees.

The organic plasticity of the figure, always the focus of Moore's formal approach, is here reduced to the point of archaism, but at the same time it is lent a very real and vital presence by the expressive asym-metry of the pose. In this image of a pregnant woman Moore evokes links with nature, with the elemental processes of birth, growth, and decay in order to make manifest the integration of humankind into a universal context. *FJ*

Francis Bacon
(1909–1992)

119 *Portrait of Isabel Rawsthorne Standing in a Street in Soho* 1967
Oil on canvas, 198 x 147 cm

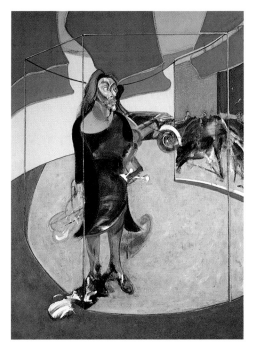

The swathed, cryptic figures in Henry Moore's "Shelter Drawings" of the Second World War were in a sense released by Francis Bacon. Born in Dublin, self-taught as an artist, and an admirer of Nietzsche, Bacon's hallucinatory scenes shed the cold light of the century of violence on the human condition.

His series of portraits, influenced by Sergei Eisenstein's silent film entitled *Battleship Potemkin* and aided by photographs (here by a picture of John Deakin), was executed in frenetic acts of painting that served less to evince the sitter's presence than to "recreate events." As Bacon told David Sylvester in 1966: "What I want to do is to distort the thing far beyond appearance, but in the distortion to bring it back to a recording of the appearance." In 1964 the artist began a series of head and full-figure portraits of his friend and fellow-painter Isabel Rawsthorne, the wife of a composer, which culminated in this 1967 view of her on a Soho street (see also *Three Studies of Isabel Rawsthorne*, 1967; Nationalgalerie, Berlin). "In this large painting," as Angela Schneider says, "the woman artist is shown standing in a kind of revolving door, a transparent cage," her face tormented, an arm and hand missing, and her statuesque poise counteracted by harsh shadows. The cage or framework isolates the figure on the stagelike circle from the surroundings: an automobile, the heads of three passersby, a phantom dog, the shapes in the background resembling awnings. The big city takes on the character of an operational field for the ambivalent vulnerability of the sitter, whom for all portrait likeness Bacon depicts as a feminine-masculine Other driven by animal instincts. Like an eye-witness, she herself is exposed to the danger of a latently aggressive situation that demands presence of mind and self-assurance. Asked about the violence done to his friends' features in such portraits, Bacon inquired in response: "Who today has been able to record anything that comes across to us as a fact without causing deep injury to the image?" *RM*

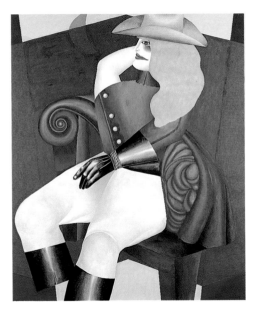

Her face, made up to masklike fixedness, displays a frozen smile. The proverbial battle of the sexes, a motif of many Lindner pictures especially in this phase, is treated with reserve in *Arizona Girl*, whose title is more descriptive than interpretative. The figure appears against a flat background divided into several large color fields. The cool blue of the uniform is heightened in intensity — though not, as so often in earlier paintings, made stridently aggressive — by the contrast with a warm triad of red, yellow, and green. Even though this palette suggests parallels with concurrent American Color Field painting, the affinity is even closer with Fernand Léger, whom Lindner greatly admired. *HJP*

Richard Lindner (1901–1978)

120 *Arizona Girl* 1975
Oil on canvas, 199.5 x 169.5 cm

This canvas was painted towards the end of the final phase of Lindner's career, which began in the early 1950s, and has since come to represent the trademark of his style. Born in Hamburg, Lindner emigrated to Paris in 1933 and to New York in 1941, and did not receive international recognition until the emergence and spread of American Pop Art in the late 1960s, although his work bore only superficial links with this movement. Although he too quoted the stereotyped images of the urban male and female propagated by the mass media, his approach continued to rely strongly on the "Neue Sachlichkeit" (New Sobriety) of his early period.

In Lindner's *Arizona Girl* of 1975, a young woman in riding costume (in the preparatory drawing, her breasts were bare) sits nonchalantly in an art deco chair. She wears a Stetson hat and has long blond hair, a strand of which she pushes back over her shoulder with a come-hither gesture.

R. B. Kitaj (b. 1932)

121 *Erie Shore* 1966
Diptych; oil on canvas, 183 x 305 cm

Kitaj's name is usually mentioned in connection with Pop Art. Born in Cleveland, Ohio, in 1932, he finished his art studies in London during the 1950s and took on a teaching post there, at which time Kitaj was indeed involved in the development of a British version of Pop Art. Yet as his 1966 canvas *Erie Shore* indicates, his aesthetic and political ambitions had outstripped those of most Pop artists even by this early date. Kitaj's subject here is the industrial exploitation and destruction of the environment on Lake Erie, the artist's home region. Various and diverse motifs are interwoven with one another in the manner of a collage, evoking a context of meaning that is difficult to decipher. "All sorts of objects from this modern industrial

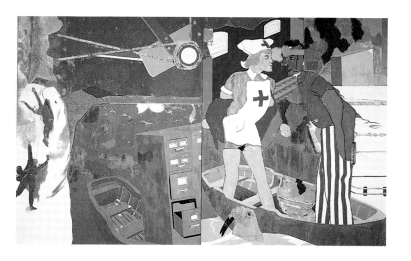

world of ours; from filing cabinets to skyscrapers," has commented Dieter Honisch, "obscure a natural environment steeped in blood red. A nurse in a miniskirt standing in a rowboat stares meaningfully at a patient who is held together by safety pins. They, too, belong to our metropolitan civilization, which walks roughshod over nature (the walrus) and indigenous tradition (the fettered Indian woman) and destroys them." *HJP*

Tom Wesselmann (b. 1931)

122 *Bedroom Painting No. 13*
1969
Oil on canvas, 148 x 163 cm

In the early 1960s a new artistic phenomenon established itself in New York: Pop Art. Tom Wesselmann, born in Cincinnati in 1931, was among the main exponents of the style.

His *Bedroom Painting* shows the characteristic tendency of Pop Art to take banal imagery from the context of either advertising or the media, and to emphasize its aesthetic qualities. The advertising device of repeating and reproducing certain striking motifs in endless series finds a correspondence here in the fact that this painting is one of thirteen variations on the same theme. *HJP*

with one another in the process of perception. In Albers's "Homages" the centers of the squares are shifted to the lower part of the composition, making the upper horizontals more substantial than the lower ones. This engenders a perceptual tension between plane and space; that is, the image appears to oscillate between flatness and depth, an effect underscored by the carefully tempered gradations of color. *FW*

Josef Albers (1888–1976)

123 *Homage to the Square: Open Outwards* 1967
Oil on masonite, 121.5 x 121.5 cm

Albers taught a master class at the Weimar Bauhaus. After the school's closure in 1933 he emigrated to the United States, where he continued his teaching activities at the recently established Black Mountain College in North Carolina. Albers concentrated on the act of seeing itself, telling his students that learning to see more sharply would increase their ability to differentiate, to recognize the relativity of facts, which eventually leads to the realization that there is no one solution to any given visual problem. In 1949 the artist began to focus on the theme of the square, producing the first of what would become a long series of variations. His "Homages to the Square," for the most part four superimposed squares rendered in fine gradations of hue, demonstrated Albers's theory of the "interaction of color." This theory derived from the insight that color was the "most relative means in art," in that its visual appearance was not alone dependent on its physical properties. The relationships established among colors altered their values, which blended and mutually interacted

Josef Albers (1888–1976)

124 *Structural Constellation N–35* 1964
Vinylite on canvas, 49.5 x 65.4 cm

While working on his "Homages to the Square," Albers began another series of oils and prints in 1949, the "Structural Constellations," which was to continue over the next twenty-five years. Also known as "Transformation of a Scheme," these geometric compositions of white lines on a black ground illustrate, in variation after variation, the structural relationships between line, plane, and space as well as the design possibilities that grew out of them. The interaction and mutual influence of form and color was the nucleus of Albers's aesthetic theory and practice. *FW*

Victor Vasarely (b. 1908)

125 *IX* 1966
Tempera on canvas, 170 x 170 cm

This composition is made up of simple elements — rhombuses within squares, silver on yellow and vice versa — arranged in rows and reversed at the end of each row. The elements cover the plane evenly, whereby the yellow grows gradually darker towards the center. This evokes a sense of depth that lends stability to the vibrating rotation of the whole, which condenses into a shadowy square at the center only to again expand outwards, a pulsar of perpetual optical energy. Part of a series of "Chromatic Transitions," when the present painting was executed Vasarely's artistic conception had reached full maturity.

Born in Hungary and a student at the Budapest Bauhaus studio of Sándor Bortnyik, Vasarely went to Paris in 1930. A brilliant draftsman, he sought early on ways to create a "pictorial alphabet" and became the most popular protagonist of the constructivist stream that, in 1963, became known as Op Art. He himself described as "cinétisme" the attempt to "advance from the plane into space, from the immobile to motion" (1954). As the smallest pictorial entity, or "unité plastique," Vasarely designed binary form-color modules, which he then systematically varied and combined into complex structures. A composition of this kind could serve as a prototype, or "score," for any number of further "performances," whether in the form of painting or relief, object, installation, or even architectural project. Vasarely's vision was nothing less than to make the multiplied work of art an integral part of the social fabric. *MT*

Frank Stella (b. 1936)

126 *Sanbornville I* 1966
Fluorescent alkyd and epoxide paint on
canvas, 371 x 264 x 10 cm

The work of Frank Stella, perhaps the
most American of American artists,
developed largely independently of
the European influences of Cubism,
Surrealism, and the Bauhaus, which
were so prevalent in the United
States during the 1950s. Settling in
New York in 1958, Stella produced a
series of stripe paintings which were
inspired by Jasper Johns's "Flags."
These then led to his famous series of
"Black Paintings," in which he bound
the spontaneous gestures of Action
Painting in the wake of Jackson
Pollock to an autonomous pictorial
order system. Employing geometric
bands of paint applied with a broad
brush, Stella attempted to establish a
solid link between the internal struc-
ture of the picture and its external
boundaries. The subject of painting
became one with the painting as
object. By thus divesting painting of
all metaphysical or literary referen-
ces, the twenty-eight-year-old artist,
who had his first one-man show at
the Leo Castelli Gallery, New York,
in 1960, established a new aesthetic
that transcended Abstract Expression-
ism. In order to expunge every trace
of illusionism, Stella then proceeded
in the 1960s to pare the surface
down to the space occupied by the
forms, producing the "Shaped Can-
vases" of which *Sanbornville I* is an
example. Rather than representing
something in the sense of a composi-
tion, the forms now stood only for
themselves. The painted image as a
secondary reality had been rendered
superfluous. This pragmatism, if not
puritanism, is typical of the funda-
mental attitude of recent American
art. Nevertheless, it reveals certain
affinities with the aims of the Euro-
pean *Nouveaux Réalistes* and the
Zero group, who likewise devoted
themselves to establishing the object-
ive character of the image. DH

Ellsworth Kelly (b. 1923)

127 *Gray Panels* 1976
Oil on canvas, 175 x 450 cm

Leon Polk Smith (b. 1906)

128 *Correspondence White-Black*
1962
Oil on canvas, 173 x 152 cm

To both protagonists of Hard Edge Abstraction, Ellsworth Kelly and Leon Polk Smith, it was less important to establish the reality of form than to find a concise formula for the phenomenon of the painted image. Kelly, in *Gray Panels*, places four panels of different dimensions and color values next to one another, engendering solely through this juxtaposition an impression of spatial relationships in the eye of the viewer. We find ourselves standing not in front of a flat, four-part picture but within an imaginary space evoked by an interaction between our sense of perception and the painted configuration.

 Leon Polk Smith's *Correspondence White-Black*, acquired directly from the artist's New York studio, was painted during his most significant artistic phase — a phase that made him the father of the Hard Edge movement. Born in 1906 as the son of a farmer on Indian territory in Oklahoma, Smith worked in New York in the 1940s. There he came under the influence of Piet Mondrian, who was then developing his mature style, and who had found support among the American Abstract Artists — an artists' group formed in 1936.

 Smith, as early as 1958, created first shaped canvases in which the painting edges were brought into conformance with its internal forms, thus anticipating developments in American art such as those later seen in the work of Stella. In *Correspondence White-Black*, two shapes are interlocked such that neither dominates the other. Smith's ongoing concern is to achieve an absolute balance of form and a homogeneous pictorial plane. The figure-ground equilibrium in the interest of the image, a device derived from Matisse that plays a prime role in both Kelly's and Smith's work, also indicates the extent of American artists' involvement with the European tradition.

DH

Barnett Newman (1905–1970)

129 *Who's Afraid of Red, Yellow,
and Blue IV* 1969–70
Oil on canvas, 274 x 603 cm

Next to Pollock, Barnett Newman
was perhaps the most significant
artist on the New York scene in the
1950s and 1960s. Like no other he
succeeded in reconciling the diverse
trends flourishing in the world's
fledgling center of art, including their
European progenitors, into a syn-
thesis of form, color, and function of
the image while considering the role
of the viewer, as well as providing
an ethical and philosophical under-
pinning for his approach.

Born in 1905 into a Polish Jewish
immigrant family, Newman attended
the Art Students League, and read
widely on scientific and philosoph-
ical topics. He worked as an art
instructor, a university lecturer, and
an art critic, closely observing the
emergent new art and forming
friendships with painters such as

Smith, Still, Motherwell, and Rothko.
After Surrealist-influenced begin-
nings in the 1940s, Newman soon
began to produce large-format
abstractions. The first culmination
of his work may be observed in *Vir
Heroicus Sublimis* of 1950–51 (The
Museum of Modern Art, New York),
a monochrome red painting divided
by four vertical bands, which appear
to float at various depths within the
image. The surface appears simulta-
neously flat and spatial, an effect that
inexorably draws the viewer into it.
Between 1958 and 1966 Newman
devoted himself to a series entitled
"Stations of the Cross," austere im-
ages reduced to black and white,
which were shown in 1966 at The
Guggenheim Museum and are now
in the National Gallery, Washington,
D.C. As one can see, Newman was
not afraid of addressing great and
perennial themes, though he did so
not illustratively but formally and by
analogy. His paintings ventured the
leap from the trivial to the sublime,

and challenged the viewer to do the same. This amounted to a completely new definition of the function of the image and the role of the viewer.

The present painting is part of a series of four entitled "Who's Afraid of Red, Yellow, and Blue," and is the last canvas Newman completed before his death in 1970. The first version, of 1966, is now in a New York private collection; the second, of 1967, is in the Staatsgalerie, Stuttgart; the third, severely damaged version of 1966–67 is in the Stedelijk Museum, Amsterdam. Within his not very extensive oeuvre, this series represents not only Newman's legacy but also a self-confident and autonomous reply to the European tradition, in which color, even the primary colors as employed by the Bauhaus and De Stijl, required a superordinate justification in order to obtain meaning within the picture. For Newman, colors were simply what they are, and were defined solely in terms of intensity and extension.

Reading from left to right, our work consists of a red square painted in layer after layer of glazes; then a deep blue band of about the width of a man's shoulders; and finally, a translucent yellow square. The viewer, whose standpoint tends to orient itself towards the quiet blue band in the middle, experiences the red as advancing towards him and the yellow as receding. Thus the viewer, as it were, becomes the midpoint of a color-space that appears to extend around him. Malevich and Matisse were masters of this art, in which artist allies with viewer in a way that, both highly pragmatic and strangely spiritual, challenges our perception to the utmost. *DH*

Morris Louis (1912–1962)

130 *Bower* 1958
Acrylic on canvas, 243 x 349 cm

Born in Baltimore in 1912, Morris
Louis, like Cy Twombly, was one of
the American artists who found more
immediate recognition in Europe
than at home. Although he went to
New York as early as 1930 and met
Jack Tworkov and Arshile Gorky
there, he formed no lasting ties to the
busy metropolis. The key encounter
came in 1952, when Louis met Ken-
neth Noland, a fellow-instructor at
the Workshop Center in Washington,
D.C. Noland introduced Louis to
Clement Greenberg, the eminent
New York critic. Greenberg in turn
established an important contact
with Helen Frankenthaler, who had
developed a technique of dyeing
large-format canvases with extremely
thinned oils, creating an, as it were,
incorporeal bond between paint and
support. This differentiated employ-
ment of translucent colors, which
Louis adopted, recalled European
approaches and led to a coloristic
sensibility, which distinguished what
soon became known as the "Wash-
ington School" from the New York
School. In *Bower*, the technique is

used to create a flowing, abstract
shape that distantly recalls curtains
with light and shadow playing across
them. Like Stella, Louis developed
his ideas in series of paintings. *Bower*
of 1958 belongs to a series collect-
ively titled "Veils," whose effects
were produced by pouring thinned
paint on a canvas placed on the
floor. *DH*

Morris Louis (1912–1962)

131 *Beta Zeta* 1960–61
Acrylic on canvas, 255 x 439 cm

Similar to Van Gogh, Louis's oeuvre
was produced in the space of a few
short years. The early "Veils" were
succeeded by a series of paintings
employing ever more intense color
called "Unfurleds," followed in turn
by a series of "Stripes." In *Beta Zeta*
of 1960–61, one of the "Unfurleds,"
Louis allows the paint to flow in just
the opposite direction of that in the
"Veil" canvases, forming rivers and
tributaries across the corners. Instead
of being confronted with a diapha-
nous central form, the viewer finds
himself, as it were, in a valley be-
tween two slopes, which the eye
cannot simultaneously take in. As the

eye wanders from one to the next, finding no hold in the center, a feeling of being enclosed between the accentuated edges of the canvas begins to emerge.

At the time this work was created, Louis worked in a tiny studio, which permitted him to paint only half of his enormous canvases at a time. He folded them down the middle; the resulting creases can still be seen. Lacking storage space, Louis rolled the finished paintings on great tubes, never looking at them again until one of his few shows, at which point he had them put on stretchers. Thus the dimensions of his pictures, most of which were determined by specialists after his early death, cannot be considered authentic. A homogenous flux of form was more important to Louis than the demarcated rectangle in which it appeared. *DH*

Mark Rothko (1903–1970)

132 *Reds Number 5* 1961
Oil on canvas, 177.8 x 160 cm

Born in Russia in 1903, Rothko emigrated with his parents to the United States in 1910. His introspective oeuvre, similar to that of Ad Reinhardt, played a key role in the new American art. Unlike, say, the younger Frank Stella, Rothko considered paint not merely a means to cover or color a canvas but a medium to convey emotions deeply rooted in religious faith. *DH*

Color Field Painting and Hard Edge Abstraction 107

Günter Fruhtrunk (1923–1982)

133 *Light-Grounded Darkness (Challenge)* 1976
Acrylic on canvas, 195 x 308 cm

Fruhtrunk's materials were the fundamental shapes of geometry. After a brief study of architecture he turned to painting, later authorizing only the work done from 1954 onwards, initially in Paris. Fruhtrunk took his point of departure in Constructivism and the Suprematism of Malevich, in the work of Arp, Delaunay, Herbin, Léger, and Vasarely. His work evinces a rejection of every form in nature except for anorganic, geometric structures; it avoids all ideas and concepts attempting to go beyond the concrete forms and colors in the painting. Structure and color, balance, rhythm, and light represented the *Foundations of Perception* ("Sinnenfundament," the title of Fruhtrunk's last canvas, also in the Nationalgalerie) and reflected an uncompromising attitude to life projected into painting. In *Light-Grounded Darkness* and other works of the 1970s, Fruhtrunk abandoned his earlier preference for narrow bands of color in favor of larger, spontaneously established color fields, into which line was introduced as a supplementary visual element. This, as Dieter Honisch points out, "lends order to a color grown increasingly autonomous." *JM*

Rupprecht Geiger
(b. 1908)

134 *Tafraoute* 1965
Oil on canvas,
250 x 270 cm

Geiger was self-taught as an artist. Encouraged at a young age by his father, the painter Willi Geiger,

he increasingly devoted himself to painting after the war, whenever his work as an architect permitted. He approaches painting on the level of "color released from every representational task" (Dieter Honisch). With his modulated monochrome "color-forms," he attempts to define the volume which, as he said in 1972, "color needs in order to arrive at a convincing statement about itself." Like the American Color Field painters or Josef Albers, Geiger avoids linear demarcations of the "element of color," and often employs unconventional, irregular picture formats. He has a penchant for red, as it combines intensity and luminosity with emotional associations. This predestines it, stated Geiger in 1978, to replace "the substantiality and ideality of objects" by an absolute achieved through the "approach to and treatment of coloration." *JM*

Georg Karl Pfahler (b. 1926)

135 *S-BBSS* 1968
Acrylic on canvas, 201 x 202 cm

With the concept of a "formative" painting Pfahler distanced himself around 1960 from *L'Art informel*. His cycles of paintings show a strong affinity with American Hard Edge and Color Field painting, with the work of Josef Albers and Barnett Newman. Pfahler similarly seeks to liberate color from all constricting boundaries, treating it not as a planar but as a perceptual phenomenon. Thus his compositions are based on the intrinsic value of color and its shifts as lightness and contrast shift. Ultimately, he selects a color for its correspondence with a second one, whose intensity and shape counterpoints the first to produce an effect of opening up "the space" of image. *JM*

Franz Gertsch (b. 1930)

136 *Barbara and Gaby 3/74* 1974
Acrylic on cotton, 270 x 420 cm

Gertsch once said, in 1974, that what interested him "about painting was not the art but the life." His motifs are accordingly drawn from series of photographs or slides; the first step he takes in determining a composition is to select a photograph from a great number of authentic, unposed pictures that show the subject from every conceivable angle. His method of painting, which since 1969 also includes making use of slide projections, reduces the subjective personal touch to a minimum, and reflects what Gertsch in 1980 called his "search for stylelessness."

Barbara and Gaby was painted in Berlin, where the Bern-based artist spent several months on a German Academic Exchange Service scholarship. It is an odd double portrait in that the two girls are turned away from us, and not even the mirror shows more than a section of the interior. The resulting anonymity of the figures underscores the seemingly chance nature of the scene. It would seem as though Gertsch is interested less in depicting two young women sharing the same living space than in characterizing their personalities by means of the objects they surround themselves with. Obviously their attitude to these things runs counter to every visual paragon propagated by advertising. The cosmetic products depicted have been divested of their function as a medium of a norm that, promising youth and beauty, offers merely a uniform camouflage dictated by fashion. The pall of mundanity has descended on the dream. It is precisely at this point that Gertsch formulates his conception and definition of painting, when he emphasizes — unlike the American Photorealists — that "human beings can [infuse] things with their presence even when they do not appear in the picture" (1980). JM

Konrad Klapheck (b. 1935)

137 *Glory and Misery of the Reforms* 1971–73
Oil on canvas, 257 x 337 cm

Inspired by a confrontation with Dalí's Surrealist imagery, Klapheck in 1955 painted the first in a long line

of pictures of machines: a precisely rendered typewriter. At the time a student of Bruno Goller at the Düsseldorf Academy, he had found his style and vocabulary in the completion of an academic assignment to paint a still life. Yet two years of hesitation followed before Klapheck returned to the subject of machines, to paint a sewing machine (*The Insulted Bride*) that recalled Lautréamont's famous ideal of beauty, which had become an axiom of Surrealism.

Unlike the Surrealists, however, who depicted imaginary juxtapositions of things in a realistic manner, Klapheck focuses on individual mechanical objects depicted in profound isolation. The artists primarily depicts small appliances on a large scale, which strangely reveals their anthropomorphic qualities. Large machinery, whose actual proportions are depicted only slightly altered, like the bulldozer in our painting, is rare in Klapheck's oeuvre. But like all of his machines, the tracked vehicle represents anything but an apotheosis of engineering and technology. The detailed, seemingly precisely rendered mechanisms would never work, as any mechanic could tell you. For all their sharply focused objectivity, Klapheck's painted machines do not conform with realistic visual conceptions, but enter a pictorial space of a kind that leaves the viewer wondering. The title, *Glory and Misery of the Reforms*, possibly refers collectivization in East Germany. However, any pathos evoked by the title vanishes in the face of this oversized machine, rising up mysteriously against the sky, seen from a low vantage point like that of a boy lying on his stomach and imagining his toy to be huge, powerful, and real. As Peter-Klaus Schuster says, we indeed "can only conceive of ourselves as very tiny creatures when confronted by this intimidating monster."

We as viewers feel ourselves transported into an "Alice in Wonderland" world, or as though we were participating in one of Gulliver's travels among the Brobdingnagians and Lilliputians invented by Jonathan Swift, to raise an ironic monument to the relativity of human aspirations.

EB

peace or Henry Moore's sculpture, *Warrior with Shield.* "The objective world depicted," explained Tübke in 1966, "is oriented towards the coordinate system of the judge's consciousness, using an additive method.... Everything is given relatively equal value — victims, terror, perpetrators.... The whole is strident, 'painted against the grain'."

Tübke's detached, cool painting technique, which relies heavily on precise drawing, is combined with an agitated and complexly interwoven plot. Influenced by medieval German painting, Italian Mannerism, and the suggestively ambiguous symbolism of Max Klinger, the Leipzig artist consciously employs the device of alienation to encourage a critical review of history. *FJ*

Werner Tübke (b. 1929)

138 *The Memoirs of Schulze, LL.D. III* 1965
Tempera on canvas on wood,
188 x 121 cm

This painting is the third version in a cycle of eleven works of 1965 to 1967, in which East German artist Werner Tübke addressed the subject of fascism and the corruption of the judiciary under National Socialism. The center of the composition is occupied by the resplendently gowned figure of a German judge, an oversized marionette surrounded by a macabre kaleidoscope of scenes and events from his life: on the right, an evocation of the idyllic but hypocritical background from which we came; on the left, the brutal consequences of his activity. The circle of past events combine to form the foreground with symbols of warning and hope, such as Picasso's dove of

Bernhard Heisig (b. 1925)

139 *Persistence of Amnesia* 1977
Oil on canvas, 151 x 242 cm

Active in Leipzig until just a few years ago, Bernhard Heisig is a master of pictorial space. His complex interweaves of expressively rendered figures accented by strong colors can be traced back to the *theatrum mundi* of a Max Beckmann and to the art of a Lovis Corinth or Oskar Kokoschka.

Reflection on the Second World War and its aftermath is one of Heisig's central concerns. In the left-hand background of *Persistence of Amnesia*, he quotes the central panel of Dix's triptych depicting scenes from the First World War. In front of it a frenetic pageant of survival is

underway: a mutilated war veteran still proud to display his Iron Cross, a hypocritical banner reading "We are All Brothers and Sisters Nevertheless," couples making love, people in cages, loudspeakers, strident media imagery, the figure of a fool blowing a trumpet — all constricted within a stiflingly enclosed space. This is an image of anxiety, the egotism of lust, the violence that still pervades postwar society, and at the same time a warning that repressing the sins of the past can be fatal. _FJ_

trees where children play suggests a last refuge for the individual, surrounded by the anonymous fields of collective agriculture. Mattheuer directs our gaze to the threatened environment, and reaffirms his continual concern to shed a critical light on reality, especially under socialism. "After all, I really do want to move people, disturb, excite them," he wrote in 1983. "That encompasses all forms of artistic statement: harmony, recording of facts, joy, outcry, protest." This stance, combining utopianism with social critique, is evident throughout the oeuvre of the Leipzig artist. _FJ_

Wolfgang Mattheuer (b. 1927)

140 _A Wide Field_ 1973
Oil on hardboard, 105 x 128.5 cm

A sublime transformation of real circumstances into symbolic metaphors, rendered in an objective style with an intense palette, characterize Mattheuer's approach. His _Wide Field_ — a quote from Theodor Fontane — took its inspiration from the German Romantic tradition and "Neue Sachlichkeit" (New Sobriety) of the 1920s, but addresses a very current issue. The little copse of

ed, rendered in a highly expressive, gestural style. In the present work, the kneeling figure bends slightly forward as if out of a shadowy, protective nook. The stonelike hues of the skin are relieved by flashes of red from the underpainting. The figure seems to be conducting a monologue, introspective, self-contained, as if caught between activity and resignation, life and death. In their existential connotations and fissured, compact corporeality Böhme's figures bear close affinities with those of his sculptor-colleague, Werner Stötzer. Both attempt to "achieve expression through forms." *RM*

Lothar Böhme (b. 1938)

141 *Kneeling Nude* 1992
Oil on canvas, 159 x 119 cm
On loan from the artist

Böhme comes from Harald Metzkes's "Berlin School." His early Cézannesque paintings of tranquilly reclining female nudes began to give way in the 1980s to archetypical individual figures, kneeling, reclining, or seat-

Werner Stötzer (b. 1931)

142 *Large Reclining Female Figure* 1970–72
Sandstone, 33 x 145 x 52 cm

"I revere stone — it sets limits. It is eons old, and its hardness forces you to act sensibly.... Stone leads to the essential," confessed Werner Stötzer

in 1973. Born in Thuringia and a student of Gustav Seitz from 1954 to 1958, Stötzer welcomes the resistance of his material, just as he prefers intransigent and striking motifs. His figures often appear in an attitude of suffering or mourning, bent, convulsed, turned away from the outside world. "Not having pity but truly empathizing, that's what triggers activity," says the sculptor. "And that's the source of my basic theme: disasters and idylls." Not even his reclining figures achieve calm; for all their condensed corporeality they communicate a sense of inward agitation, a consciousness of menace combined with animal vitality. *Large Reclining Female Figure*, one of Stötzer's major works, was acquired by the Nationalgalerie immediately after its completion. In its condensed volume and tense muscularity, the figure combines a longing for repose with an agitated nervousness suggested by the accentuated rhythmic patterns of the masses. The human anatomy is reduced and fragmented, but at the same time exaggerated and heightened, charged with intense energy. Stötzer treats the organic human form as a holistic symbol, inviolable at the core but nevertheless incomplete, conveying the impression of the body as a timeless, primeval landscape. *FJ*

Walter Libuda (b. 1950)

143 *The Locks* 1987–88
Oil on canvas, 200 x 175 cm

Libuda's paintings have a *mise-en-scène* character that reflects his studies with Bernhard Heisig from 1973 to 1979. They are suffused by a vital dramatic impulse whose roots lie in German Expressionism, in Beck-mann, or in the violent gestural painting of the Cobra group. This Neo-Expressionism, adopted by a self-confident younger generation of artists not only in the West but also in the East, reflects their disquiet and protest, but also an attempt to restate the fundamental issues of life and society. Libuda's *Locks*, painted in agitated, vibrant strokes, evokes a garishly spotlighted crowd of figures, border guards and people attempting to escape, emerging from a dark tunnel that seems to metamorphose into a saving boat. Oscillating between demonism and realism, the picture holds up a distorting mirror to life in the GDR and the wave of escape attempts at that period, but it is also a metaphor for helplessness and violence as such. "Ideas for paintings," said Libuda in 1984, "do not emerge from concrete, specific occasions. They are the result of my accumulated experiences, which find their translation on the level of the image."
 FJ

Tadeusz Kantor (1915–1990)

144 *Infanta* 1966
Mixed media, 183 x 127 cm

Tadeusz Kantor was the key figure in Polish art of the 1960s and 1970s. His *Infanta* belongs to a major sequence of works collectively entitled "Emballages" (Packagings). By consciously employing trivial, unprepossessing materials and objects, which he called a "degraded reality," Kantor drew attention in these works to current issues and situations in

Polish life and art. Back in the 1950s the artist had found his aesthetic ideal in the gestural painting of French *Art informel*, in which he recognized the amorphous structures that would also come to characterize his later theater performances.

After 1956 he began increasingly to devote himself to the performing arts, including Happenings, and became a theater reformer in many respects. Kantor's great significance resides in his ability to integrate very diverse fields, such as painting and stage direction, poetry, set design, and art theory.

Kantor's statements in whatever medium have an open-ended, discontinuous character that was very much intended. This is seen to good effect in *Infanta*, which combines an actual dilapidated school bag with a sketch of a girl's head, a quote from Velázquez's famous painting. The old worn bag is an extremely evocative symbol, but Kantor, the "perpetual roamer," leaves it closed and its contents up to the viewer's imagination.

BS

Zdeněk Sýkora (b. 1920)

145 *Composition* 1966
Oil on canvas, 220 x 180 cm

Born in 1920 in Louny, near Prague, Zdeněk Sýkora is one of the leading representatives of Constructivist art in his country and a pioneer of computer art as well. In 1962 he began to develop a vocabulary of geometric forms and to concentrate on serial structures. The result was a group of works in which a system of geometric elements covers the picture plane like a network, creating an impression of depth and sequential motion. A juncture that would prove crucial to his development came in 1964, when Sýkora collaborated with the mathematician Jogoslav Blažek to design a program for the legendary LGP–30 computer, with the aid of which geometric shapes and struc-

tures could be determined and calculated. Relying expressly on the workings of chance, visual modules were suggested, which took into account the problem of distribution on the picture plane as well as various formal interrelationships. Based on this score, the sequences of black-and-white shapes were then filled in with oil paint on canvas. *Composition* of 1966 was done by these means, which Sýkora continued to employ until 1972. The more or less anonymous element of the circle served the artist in constructing a complex field. The palette, reduced to two values, functions both to provide contrast and to structure the field. The picture shows no traces of personal touch or emotion. This calculated rigor runs counter to conventional notions of art, and in fact, after the revolutionary "Prague Spring" of 1968 came to an end, it was condemned to a marginal role. *BS*

the work draws attention to the altered definition of painting in our century, by which the painted image, declared autonomous, was no longer considered suitable for the depiction of reality. Like Magritte and Picasso, Duchamp drew his conclusions from this insight, and stated that art was ultimately a matter of definition. Lakner sets a written quotation on canvas to indicate that language is necessary to formulate thought, and traces a train of thought in which the coded meaning of phonetic sounds is reflected in the abstract symbols of characters. *BS*

László Lakner (b. 1936)

146 *Marcel Duchamp* 1976
Oil on canvas, 190 x 140 cm

Born in Budapest in 1936, Lakner came to Berlin in 1974 on a grant from the German Academic Exchange Service (DAAD), and has lived here ever since. During his first Berlin years Lakner worked primarily in a typographical mode, joining a stream of twentieth-century art in which art and language are closely interwoven. The painting in the Nationalgalerie, dating to 1976, belongs to a series devoted to Marcel Duchamp, who is evidently one of Lakner's admired predecessors. Done in an Old Masterly technique,

Günther Uecker (b. 1930)

147 *Forest* 1984
Linden wood; nails, mixed media,
height 170, 165, 138, 133, 120, 100,
93, and 88 cm (eight parts)
Property of the Verein der Freunde der
Nationalgalerie

The use of innumerable, closely
spaced nails that give an impression
of fields of grain swaying in the
wind has become the trademark of
Günther Uecker's art. From 1960 to
1966, in collaboration with Heinz
Mack and Otto Piene of the Zero

group, he concentrated on the
expressive force of rhythmically
articulated patterns of light and
shadow (see no. 109).

Besides creating many reliefs in
this mode, Uecker has used nails
since the middle of the 1950s to
transform pieces of wood and leath-
er, or mundane things like tables,
chairs, and television sets into fetish-
like objects. But it was not until
1980, after a performance involving
a felled tree at Galerie Brusten, Wup-
pertal, that the artist began to take
untreated timber as his point of

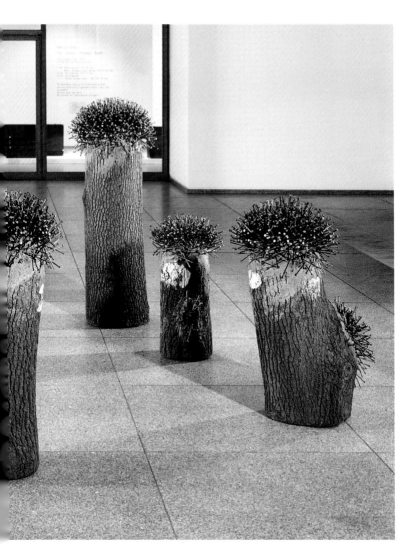

departure. Since then, several versions of similar, multipartite works entitled *Forest* were executed, that of 1984 in our collection being the first in the series. The eight sections of tree trunks of different heights, topped by bristling nails that recall grassy growths or even crowns of thorns, have the effect of rigid columns which nonetheless still contain traces of organic life. The contrast between organic substance and inorganic, man-made implement engenders an eerie sense of estrangement, which is further heightened by the tectonic solidity of the trunks as opposed to the vitality, even playfulness, of their crowns of nails. This loose spatial arrangement conveys a silent protest against the menace man poses to nature, but it also symbolizes the natural character of transience and transformation, as the truncated trees seem to metamorphose into fabulous creatures infused with an enigmatic life force witnessed only in dreams. *FJ*

"François Morellet" exhibition, held from Jan. 15 to Feb. 20, 1977

Exhibitions

Since the opening of the Neue Nationalgalerie in autumn 1968 a series of special exhibitions has continually changed the aspect of the museum and largely determined its atmosphere. Conceived as supplements to and extensions of the permanent collection, they established substantial, ever-new visual contexts, whether they were devoted to the pioneers of modernism or to recent contemporary art. The Upper Hall with its soaring 8.80-meter-high ceiling and circumambient glazing proved the greatest challenge to the art historians and artists who designed the exhibitions, for it required all their ingenuity to do justice both to the art and the architecture.

The museum dedication was accompanied by a Mondrian retrospective in which the works were displayed on Mies van der Rohe's suspended partitions. This was followed in 1969 by a show of the

"Alberto Giacometti" exhibition, held from Oct. 9, 1987 to Jan. 3, 1988

"a.r. penck" exhibition, held from April 24 to June 5, 1988

Ströher Collection, then in 1970 by a Matta and in 1971 by a Rothko exhibition. François Morellet, too, suspended his large-format panels from the ceiling in his 1977 show in the Upper Hall, setting the concentrated, dynamic rhythms of his compositions against the hall's tendency to appear infinitely expansive. Other artists attempted to tame the space by

"Positions in Contemporary Art" exhibition, held from June 24 to Sept. 18, 1988. Right: Mario Merz's *Drop of Water* igloo, 1987; left: Jannis Kounellis's painting *Untitled*, 1986

"Panamarenko" exhibition, held from May 18 to July 30, 1978

means of compact installations or space-defining objects. Kenneth Snelson, for instance, constructed a large, multipartite, filigree sculpture here in 1977, while Panamarenko, in 1978, installed virtual flying machines and an enormous airship that appeared to physically support the heavy coffered ceiling. Franz Erhard Walther, in 1981, and Alf Lechner, in 1985, cleared the hall of every mobile partition and installation, and worked with the space as Mies had intended it: a special,

delimited site which is separated from the outside world only by its high glass walls. The 1987–88 arrangement of Giacometti's sculptures — the never-realized first design for Chase Manhattan Plaza in New York, striding male figures, steadfastly standing female figures, and a larger-than-life head — took on exemplary significance, and could be experienced as a symbolic reflection of a real situation. Penck, in contrast, had the partitions extended right up to the ceiling for his 1988

show, creating the impression of surfaces arbitrarily floating above and around his mural-sized canvases — an ever-present danger for works on exhibition here. That same year Mario Merz built a five-meter-high glass igloo in the center of the hall, commenting on the architectural venue by confronting it with this fragile and transparent hemisphere. Kiefer transformed the great pillars of the hall into observation platforms, fitting them with gangways halfway up to the ceiling from which visitors could view his sculptures. His great heavy airplanes made of lead, though actually incapable of flight, seemed to have come to rest here as if in a hangar, and viewers could look down upon them in the secure knowledge of the inertia of matter.

Mies van der Rohe's grand hall has again and again given us the opportunity to design and organize the space in ever-new and unique ways, making it an integral part of the aesthetic experience. *AS*

"Anselm Kiefer" exhibition, held from March 10 to May 20, 1991

Literature related to the Neue Nationalgalerie

Karl Scheffler. *Berliner Museums-krieg.* Berlin, 1921

Ludwig Justi. *Von Corinth bis Klee.* Berlin, 1931

Ludwig Justi. *Im Dienste der Kunst.* Breslau, 1936

Vera Ruthenberg and Walter Heese. *National-Galerie, Berlin.* Leipzig, 1963

Paul Ortwin Rave. *Die Geschichte der Nationalgalerie Berlin.* Berlin, 1968

Werner Haftmann. *Die Neue Nation-algalerie. Staatliche Museen Preus-sischer Kulturbesitz*, Berliner Forum. Berlin, 1969

Alfred Hentzen. "Die Entstehung der Neuen Anteilung der Nationalgalerie im ehemaligen Kronprinzen-Palais," in *Jahrbuch Preussischer Kulturbe-sitz*, vol. 10, 1972. Berlin and Cologne, 1973

Alfred Hentzen. *Die Berliner Natio-nalgalerie im Bildersturm.* Cologne and Berlin, 1971

Alfred Hentzen. *Die Nationalgalerie Berlin.* Recklinghausen, 1979

Nationalgalerie Berlin, Staatliche Museen Preussischer Kulturbesitz. *Kunst der Welt in den Berliner Museen.* Stuttgart and Zurich, 1980

Nationalgalerie Berlin. Braun-schweig, 1980

Annegret Janda. *Das Schicksal einer Sammlung. Die Neue Abteilung der Nationalgalerie im ehemaligen Kron-prinzen-Palais.* Berlin, 1986 (revised edition 1988)

Peter Betthausen. *Nationalgalerie Berlin Museumsinsel.* Munich, 1990

Annegret Janda and Jörn Grabowski. *Kunst in Deutschland 1905–1937. Die verlorene Sammlung der Natio-nalgalerie im ehemaligen Kronprin-zen-Palais.* Berlin, 1992

Dieter Honisch. "Ein wichtiger Schritt zur Neuordnung der Samm-lung des 20 Jahrhunderts in der Neuen Nationalgalerie," in *Jahrbuch Preussischer Kulturbesitz*, vol. 30, 1993. Berlin, 1994

Press coverage regarding the "deut-sche Bilderstreit," in *Jahrbuch Preus-sischer Kulturbesitz*, vol. 31, 1994. Berlin, 1995

Index of Artists

Unless otherwise stated, the numbers refer to the figure numbers throughout the book.

Library of Congress Cataloging-in-Publication Data

Neue Nationalgalerie Berlin / [edited by Roland März and Angela Schneider : translated from German by John William Gabriel].
 p. cm. — (Prestel museum guide)
Includes bibliographical references and index.
ISBN 3-7913-1732-6 (softcover)
1. Neue Nationalgalerie (Germany)—Guidebooks. I. März, Roland. II. Schneider, Angela. III. Series. N2233.N39 1997
708.3'155—dc21 97-190